EAST-
MEETS-
WEST

Quilts

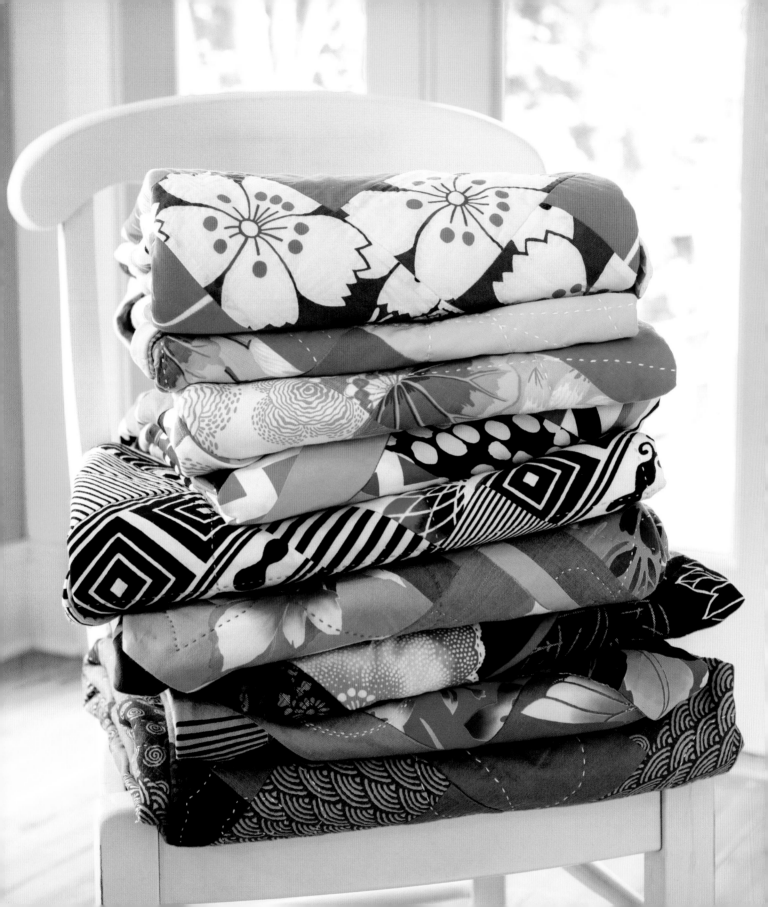

EAST-MEETS-WEST Quilts

Explore Improv with Japanese-Inspired Designs

Patricia Belyea

PHOTOGRAPHY BY KATE BALDWIN

ABRAMS, NEW YORK

**THANK YOU
TO FIVE SPECIAL WOMEN:**

my mom, Jane,
who always encourages me;

my mentor, Maurine,
who shared so much with me;

my twin, Pamela,
who ceaselessly supports me;

and

my daughters, Liz and Victoria,
who let me be their mom.

Contents

Introduction

Welcome to my style of improv quilting, where Americana broken-rail blocks meet extraordinary Japanese fabrics. In combining elements from two diverse cultures, something new has emerged. I haven't made these quilts umpteen times in a test studio, refining the colors, block placement, and stitching patterns until they're perfect. Instead, I've embarked on a personal adventure with each of these quilts. I want to teach you how to do the same.

CREATIVE FREEDOM

For me, it's all about exploration. Developing my own pattern logic inspires my imagination. I love seeing the visual evolution as my quilts come together. My first action informs the next. Each step is filled with doing and discerning to bring my quilts to completion.

I invite you to make quilts with a similar intention. Enjoy the delight of discovery as you try something new. Give yourself permission not to know exactly where you are going. Yet note that creating improvisational quilts is never arbitrary or accidental: It requires active discernment in determining each design choice.

When improv quilting, remember: It's only fabric! Freestyle fabric cutting and sewing is a low-risk endeavor with a strong payoff of personal growth and empowerment. As you push into uncharted design territory, trust yourself. You can do this.

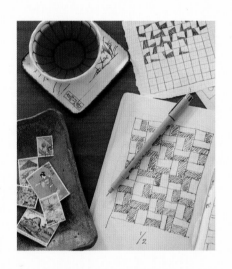

UNCOMMON FABRICS

Working with Japanese or Japanese-inspired fabric—whether vintage or contemporary—will transform your quilts into something out of the ordinary. Vintage Japanese cottons are typically hand-dyed with classic geometrics or luscious patterns. More modern fabrics offer traditional to outrageous printed motifs. And Japanese-inspired fabrics might emulate the intricate embroidery of an antique kimono or sport an anime character. Anything goes.

Treasure hunting plays an important role in collecting Japanese fabrics. This does not necessarily mean traveling to Japan and scouring the flea markets for exciting finds. Instead, try your local thrift stores, stop by estate sales, or visit the international district of your city. At your local textile shop, ask about the newest Japanese imports. The Internet is another great source: Many online fabric stores specialize in Japanese fabrics, and you can also find them on eBay and Etsy.

Your collection doesn't have to be a pile of authentic Japanese fabrics; you can also choose fabrics that remind you of Japanese motifs. The most important criteria? The fabric must please you and transport you to your vision of Japan.

GETTING STARTED

The Japanese appreciation of process rather than product aligns with my approach to improv quilting. I offer my guidance as you venture forward. Not everything can be explained by me. Instead, everything needs to be experienced by you.

If you are a beginner, all the production steps are included so you can start improv quilting. If you are an experienced quilter, you will be familiar with many of these instructions. No matter what your level of previous experience, now is the time to be curious and try new ideas—to become fully alive with experimentation and ingenuity.

Embracing
Improv Quilting

Explore Improv

ENGAGE IN THE JOY OF CREATION

The improv quilts in this book are based on the Hachi Quilt Manifesto (see page 17). The Manifesto provides you with a set of straightforward rules and gives you a place to start. The fifth and final rule is "Break any rule you like," so you also have complete creative freedom.

When I try something new, I sometimes choose to quilt like a child. Wonder and curiosity embolden me to put fabrics together in novel ways just to see what will happen. Other times I opt to quilt like a diva—boldly making moves as though I know what I'm doing. Being decisive means taking risks, but also propels me in new directions.

There is no room for church mice in improv quilting. You have to own your ideas, your choices, and your determination. No teacher or sage will be there to cheer you on. There is only you in your sewing room—cutting and sewing, discerning and reworking.

It's all very simple, but not necessarily easy. I encourage you to embrace improv quilting. Before you know it, you will be surprising yourself with a new skill set—the ability to bravely go forward and create something that is all your own.

Most Favorable Hachi

THE JAPANESE NUMERAL EIGHT

Considered lucky in Japan, the Kanji character for *hachi* translates to "eight." Hachi suggests growth and prosperity with its outward swooping lines.

The Hachi Quilt Manifesto specifies a final block size of 8 inches (20 cm). This size is perfect for flaunting the large-scale patterns of many Japanese fabrics. In addition, eight easily divides by four and two to make the Hachi Quilt block configurations with patterned and solid fabrics.

All the iterations of Hachi Quilts in this book share the common element of 8-inch (20-cm) square blocks. Beyond that, the quilts interpret the Hachi Quilt Manifesto in many diverse ways.

Hachi Quilt Manifesto

FIVE EASY RULES

1. MAKE EACH FINAL QUILT BLOCK 8 INCHES (20 CM) SQUARE.

2. MAKE BLOCKS WITH TWO FABRICS IN A RELATIONSHIP OF 1/4 + 3/4, 1/2 + 1/2, OR 3/4 + 1/4.

 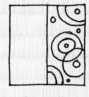 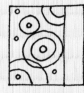

(¼ + ¾) (½ + ½) (½ + ½) (¾ + ¼)

3. SET BLOCKS IN A HORIZONTAL THEN VERTICAL REPEATING PATTERN.

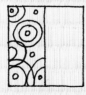 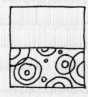

4. ADD AN UNEXPECTED VISITOR TO SPARK THE QUILT COMPOSITION.

5. BREAK ANY RULE YOU LIKE.

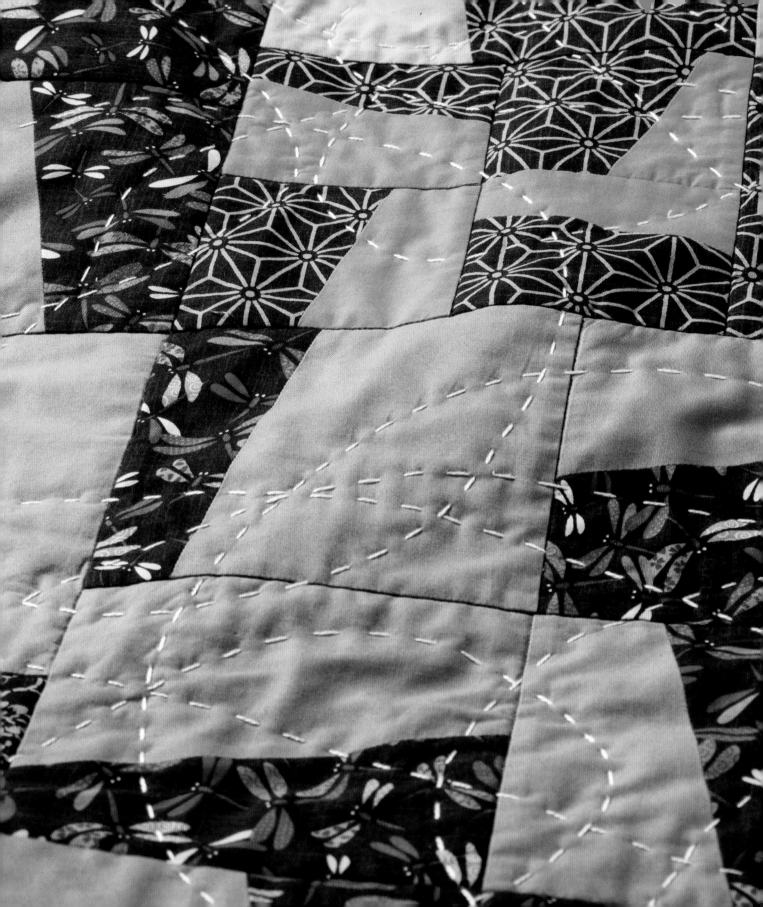

The Unexpected Visitor

Check out this scenario (note that this is not about you, because everyone knows you are easygoing and generous):

> A woman plans a perfect dinner party. She prepares a thrilling guest list and labors over every detail. She knows where everyone will sit so the conversation will be lively and entertaining. At the last minute, an unexpected visitor shows up.

> Although the hostess is dismayed, she graciously pulls up another chair to the table. The unexpected visitor contributes a superb energy to the evening. Instead of being a disaster, the party is a huge success.

Adding an Unexpected Visitor to your quilt means interjecting a fabric (or two) that doesn't match anything else—an element that seems impromptu. You need just a little of your Unexpected Visitor. This daring inclusion is often the one that gathers the most accolades and prompts questions like "How did you ever think of that?"

An Unexpected Visitor can be a color that pops or a pattern that is out of sync. You can make it obvious or subtle. As you flip through this book, checking out the Hachi Quilts, some Unexpected Visitors will be the first thing you see. Others will require a little hunting.

I can't take credit for the Unexpected Visitor. I learned about this intriguing concept from Annie Lewis when I took her collage class at Gage Academy of Art in Seattle. You don't need to attend art school to use this valuable addition to compositions. Welcome the Unexpected Visitor into your projects and watch your quilts become more interesting.

Let Your Fabric Talk to You

WORKING WITH JAPANESE FABRICS

The first step in making a Hachi Quilt is finding a patterned fabric you can't resist. Take a good look at your fabric and intuit what it is saying to you.

Is your fabric a partygoer? Does it want to be part of an effervescent quilt? Look at Sakura Spring (page 81). The white fabric with cheery blossoms inspired the animated colors and precocious composition.

Is your fabric an intriguing artistic type? For Glow (page 35), note how the brown, turquoise, and white abstract pattern encouraged striking interactions between the patterns and solids.

Is your fabric an introvert? Does it wish to curl up on a quiet layout and stay out of the limelight? Check out Lucky Owls (page 91). The low-key contrast of the patterns and colors made this quilt understated—an ideal resolve for the highlighted owl panel.

Once you have selected your feature fabric, decide which patterned friends and colored solids to add. Kabuki (page 51) did not welcome another patterned fabric into its composition. Hidden Wonders (page 73) used two almost identical patterns for the whole quilt, plus a few bold florals. On the other end of the spectrum, Harmony (page 113) included seven patterned fabrics but only two neutral solids accented with seven highlight squares.

A personality will emerge from your collected fabrics. Is this what you want to communicate? Decide whether this fabric selection is where you want to begin. You can still make adjustments on the design wall as you continually advance your project to match your vision.

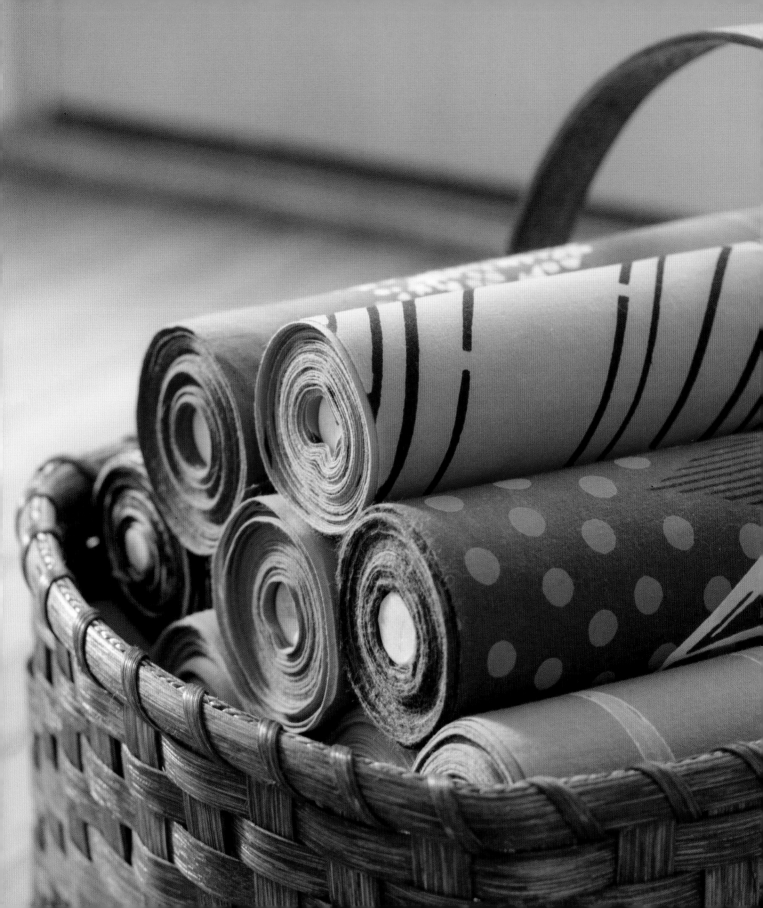

How Much Fabric?

It is important for quilters to know exactly how much fabric to buy, as the most efficient way to use fabric requires exact measurements. Would you be frustrated if I told you that the more fabric you have, the bigger your quilt can be? Such an open-ended directive might make you uncomfortable, but it's true.

This book shows quilts of many sizes. The sizes are the result of the design process and how much fabric was on hand. Also, if you are like me, you may feel excited to use a particular fabric in a project, only to later reject it on the design wall. As you see how things are coming together, you may (as I often do) make adjustments that exclude the original fabric.

Quilts made with vintage Japanese textiles tend to be smaller than ones with contemporary fabrics. Yukata cottons are 14 inches (35.5 cm) wide, so 4 yards (4 m) of the narrow-width cotton does not go as far as the same amount of 44-inch- (112-cm-) wide cotton.

For each quilt that follows, the fabric measurements were determined after the quilt was complete. You can make the exact same quilt using the amounts included in the instructions. If you want to explore your own design ideas, you will need to purchase more than the minimum amounts stated.

Please recognize that you are embarking on improv quilting, so you are working to expand your creative and intuitive spirit. Not being exact and economical might be a challenge. Please buy plenty of fabric and be prepared not to include every inch in your quilt project. Remember that you can use your scraps for many purposes, including sharing with friends.

Collecting Colors

A COLOR STASH FOR SPONTANEOUS PROJECTS

Every time you stop at a fabric shop, I suggest buying solid-dyed cottons. Choose 1 to 3 yards (1–3 m) of as many colors as you can afford that day. This helps satisfy your craving to shop and builds your library of colored fabrics for future projects.

Solid fabrics are the same color on both sides. Some are woven with dyed threads, and others are dyed as a whole cloth. Shot cotton is woven with two different thread colors for the warp and weft fibers.

I prewash my purchases, lay them out to dry, and iron them. Then I tuck my newly acquired solids into one of three bins:

- Warms: red, orange, and yellow
- Cools: green, blue, and purple
- Neutrals: white, black, gray, brown, and beige

I have an additional bin for scraps. After I am finished with a project, I throw small solid leftovers into that bin. I use these bits for small projects. Sometimes I felicitously spy an Unexpected Visitor in the collection.

PROJECT-SPECIFIC SOLIDS

Once I have assembled the patterned fabrics for a quilt, I search for solids to pair with them. Often my stash takes care of this. If I do not have the exact color on hand, I can see similar colors and get an idea of what I need.

Off I go to the store to buy another solid or two. This is never a quick trip, as I am very thoughtful about color selections. I spread out my project fabrics on any available surface. There I audition bolts of solids until I find the colors that work perfectly. Once home, I prewash my fabrics and wait patiently for them to dry so I can jump into my project.

As soon as your own fabrics are ready, it is time to get started. There is nothing holding you back except hesitation. Look through the Hachi Quilt Projects to find an idea you want to try. See the later chapters for detailed instructions on making your quilt. Ready, set, cut and sew!

Hachi Quilt Projects

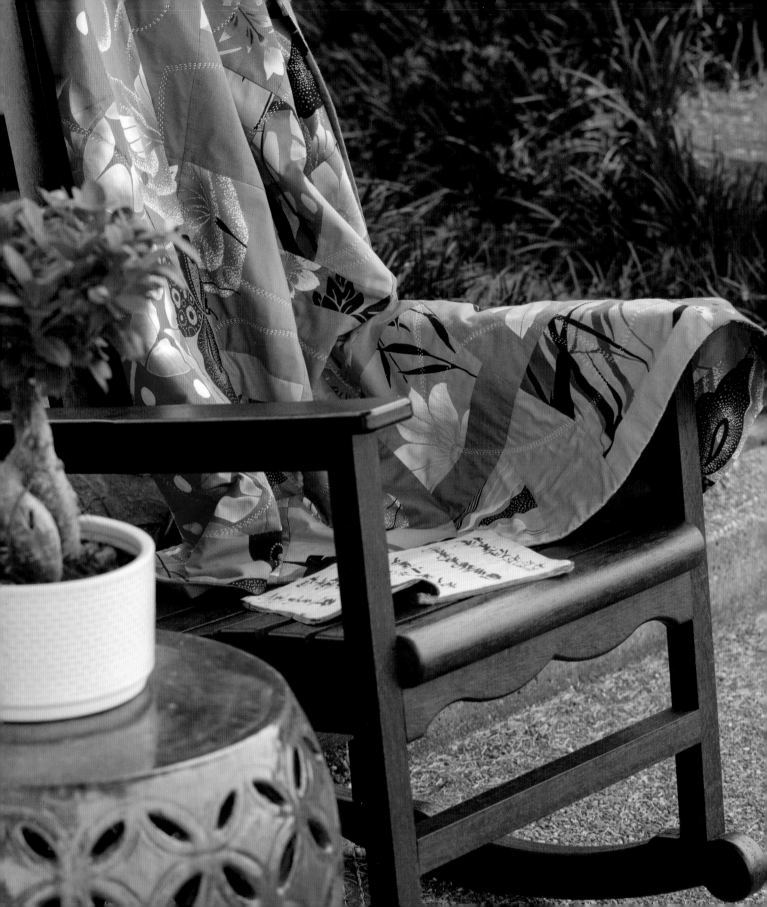

Autumn Breeze

Big Squares of Color

When autumn breezes begin to blow, the Japanese search for the changing colors of fall. The annual maple-hunting guide reports on the best viewing sites, moving from Hokkaido in the north to Kyushu in the south over a fifty-five-day period.

The fabrics you choose for a quilt have the power to communicate a mood, a personality, or even a season. This quilt tells a story of autumn. Start with a fabric that pleases you. What single word expresses the pattern? Bold? Calm? Springlike? Use this descriptor as the theme for your project. Gather together patterned fabrics that complement your original choice, but keep in mind your quilt theme. Then add solids that look great together as a palette and match the background colors of your collected fabrics. This first step determines the total look of your quilt. If you need to switch out a pattern or color, do so. You're the boss. Enjoy the process.

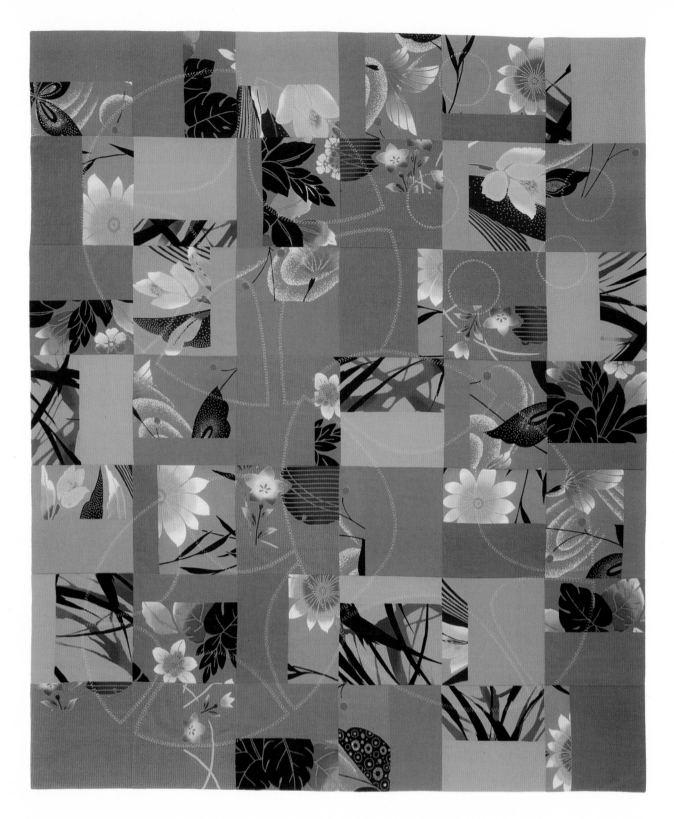

Autumn Breeze

FINISHED QUILT MEASURES
48 × 56 INCHES (122 × 142 CM)

- - - - - - - - - - - - - -

- **The background colors of the patterned fabrics match the paired solids**
- **The red blocks add energy as the Unexpected Visitor**
- **A motif from the backing fabric supplies the inspiration for the stitch design**

- - - - - - - - - - - - - -

MATERIALS

Patterned Fabrics

Six contemporary fabrics (44–45 inches [112–114 cm] wide): minimum ¼ yard (23 cm) for the red and green patterns, and minimum ½ yard (46 cm) for the brown, blue, gold, and gray patterns OR six yukata cottons (14 inches [35.5 cm] wide): minimum 2 yards (2 m) for the red and green patterns, and minimum 4 yards (4 m) for the brown, blue, gold, and gray patterns.

Solid Fabrics

Six solids (44–45 inches [112–114 cm] wide): minimum ¼ yard (23 cm) for the red and green, and minimum ½ yard (46 cm) for the brown, blue, gold, and gray.

MAKE YOUR QUILT TOP

Refer to the Make Your Quilt Top section at the back of the book for detailed instructions on making your quilt top.

Assemble your fabrics. Look for harmony within your palette, with one dissonant color. For this quilt, the bright red is the Unexpected Visitor.

Autumn Breeze is made with forty-two 8-inch (20-cm) blocks with six color combinations:

- Color A (brown pattern/brown): 9 blocks
- Color B (blue pattern/blue): 8 blocks
- Color C (gold pattern/gold): 8 blocks
- Color D (gray pattern/gray): 7 blocks
- Color E (green pattern/green): 5 blocks
- Color F (red pattern/red): 5 blocks

Make the Rough Blocks

Autumn Breeze has nine blocks with 1/4 patterns, 18 blocks with 1/2 patterns, and 15 blocks with 3/4 patterns. About 80 percent of the blocks have the larger amount of patterns. Keep this ratio in mind when you rough cut your patterned fabrics and solids.

Sew the rough blocks together and press the seams open.

Trim Out the Rough Blocks

Trim the blocks with the Cutting Dance (page 149).

Develop the Design

Place the trimmed blocks on your design wall to develop the composition of your quilt top. Try different configurations, and switch out extra blocks for more variations.

Assemble Your Quilt Top

When you are happy with your design, sew all the blocks and rows together.

- -

FINISH YOUR QUILT

Refer to the Finishing Steps section at the back of the book for detailed instructions on completing your quilt.

Make Your Quilt Back

Make your quilt back whole cloth or pieced. Use what you have on hand or seek fabrics to complement or contrast your quilt top design, keeping in mind the fabrics you have available or planned for the facing. The final size should be 56 × 64 inches (142 × 163 cm). Press all seams open.

The back of Autumn Breeze is made with 7 yards (7 m) of yukata cotton cut into four equal lengths and sewn together to span the width of the quilt back.

Make and Sew the Quilt Sandwich

Pin baste the quilt sandwich. Stitch-in-the-ditch around the blocks to secure the quilt sandwich. Tailor baste around the perimeter.

Design and Mark Your Hand-Stitching Pattern

Look at your quilt front and back fabrics to inspire your stitching pattern. The hand-stitching on Autumn Breeze emulates the abstract morning glories of the yukata cotton on the back. To make the oversize stitching pattern, overlap three 60-inch (152-cm) lengths of freezer paper by a few inches and weld them together with an iron set to medium-high. Draw the pattern on the freezer paper, then add notches for positioning the independent forms. Cut out the stitching pattern with sharp paper scissors.

Iron your stitching patterns onto the quilt top and trace around the edges with a blue water-soluble marking pen.

Hand Stitch Your Quilt

Hand stitch, following the blue lines. Echo stitch around the first line of stitching once or twice to create impact on the patterned fabrics.

Block and Trim Your Quilt

Block your quilt (see page 179), if you like. Trim your quilt and staystitch the perimeter of the quilt.

Make and Add the End Cap Facing

Refer to End Cap Facings (page 183) for detailed instructions on making and sewing on a facing.

THE STITCHING PATTERN FOR AUTUMN BREEZE.

NOTCHES IN THE STITCHING PATTERN HELP IN POSITIONING THE ELEMENTS.

The single-thick facing for Autumn Breeze is made with 4 yards (4 m) of yukata cotton plus a 7-inch- (18-cm-) wide piece of a solid. Cut the yukata cotton into two pieces, each 2 yards (2 m) long. Cut the yukata pieces in half lengthwise, yielding four 7 × 72-inch (18 × 183-cm) strips. Seam the small piece of a solid into one of the strips.

Trim the facing strips to 4¾ inches (12 cm) wide. Turn under one edge ⅝ inch (1.5 cm), using an iron.

Position the facing strips, right side down, on the quilt front. Trim the side strips to the exact length of the quilt sandwich. Trim the top and bottom strips 3 inches (7.5 cm) shorter than the quilt width. Place the top and bottom strips on top of the side strips.

Stitch on the strips with a ¼-inch (6-mm) seam allowance and turn to the back for a 3⅞-inch- (9.5-cm-) wide finished facing. Note that the sides of the facing overlap the top and bottom. Use thread matching each facing fabric for the invisible stitching.

Final Details
Name your quilt and add a label.

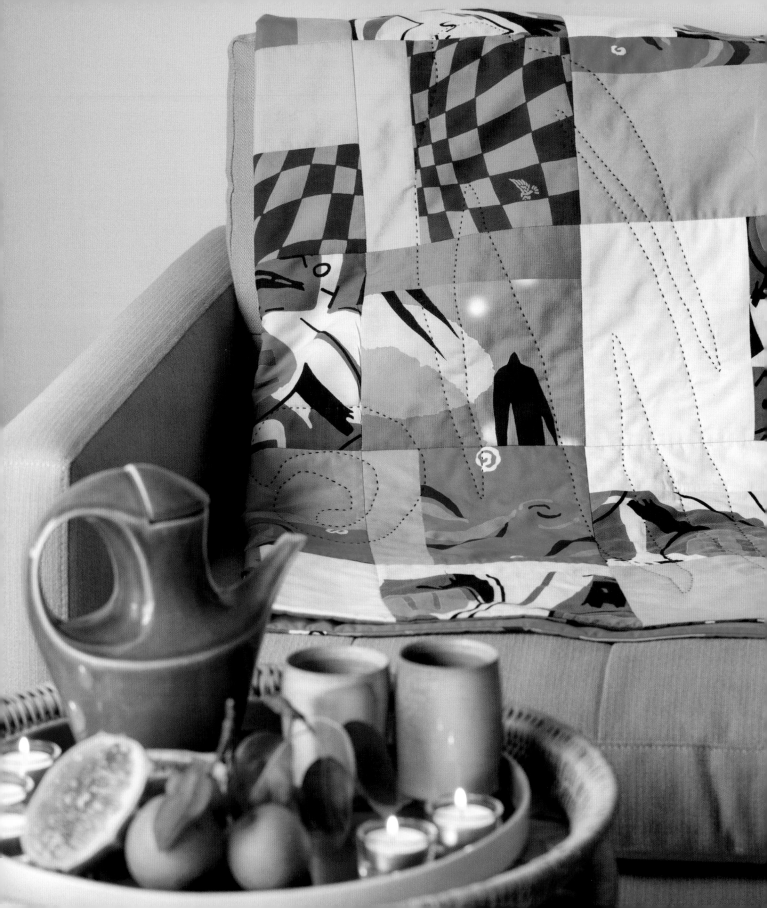

Glow

Connecting Blocks

In mid-June, fireflies create magical light shows above the waterways in rural Japan. The Japanese travel great distances to see these luminous creatures, which are believed to be the souls of warriors lost in ancient battles.

In the pink blocks of Glow, white polka dots represent beloved fireflies and Matisse-like forms symbolize the soaring spirits of fallen warriors. Add to this a checkerboard from Wonderland, a sky filled with starry swirls and sailing crescents, and a lively abstract with the word "TOKYOIKS" written across it. With such an inharmonious group of patterns, the composition needed help. By connecting many of the solid colors, the relationship between the disparate elements strengthened. Many times you will assemble an incongruous grouping of fabrics for a quilt project. Instead of spreading them evenly across your composition, try grouping similar blocks together. This approach reduces the busyness and simplifies your overall design.

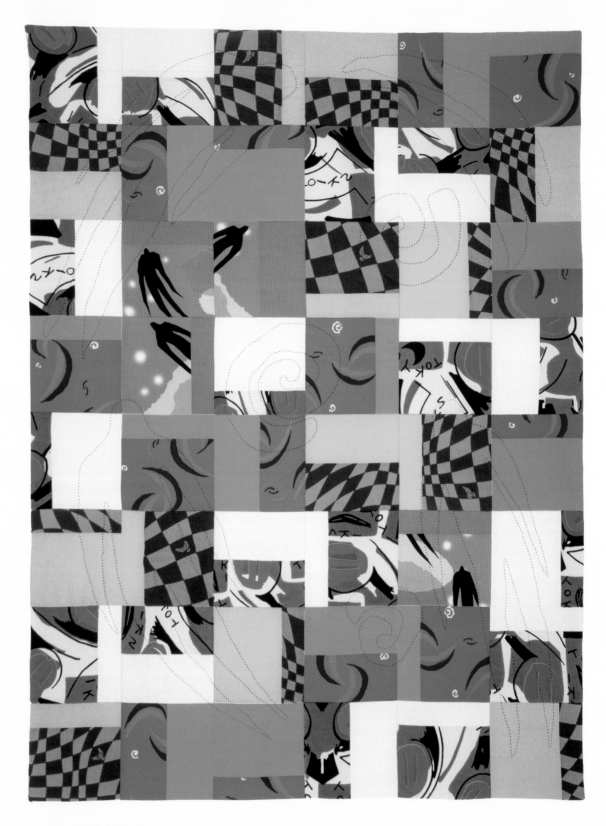

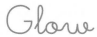

Glow

FINISHED QUILT MEASURES
48 × 64 INCHES (122 × 163 CM)

- **Solids connect to make L-shaped forms**
- **Pink blocks drop in as the Unexpected Visitor**
- **The black floating forms inspire the stitching design**

MATERIALS

Patterned Fabrics

Four contemporary fabrics (44–45 inches [112–114 cm] wide): minimum ¼ yard (23 cm) for the firefly pattern, minimum ½ yard (46 cm) for the starry sky and checkerboard patterns, and minimum 1 yard (1 m) for the brown abstract pattern OR four yukata cottons (14 inches [35.5 cm] wide): minimum 1 yard (1 m) for the firefly pattern, minimum 3 yards (3 m) for the starry sky and checkerboard patterns, and minimum 4 yards (4 m) for the brown abstract pattern.

Solid Fabrics

Four solids (44–45 inches [112–114 cm] wide): minimum ¼ yard (23 cm) for the pink, minimum ½ yard (46 cm) for the turquoise and gold, and minimum ¾ yard (69 cm) for the white.

MAKE YOUR QUILT TOP

Refer to the Make Your Quilt Top section at the back of the book for detailed instructions on making your quilt top.

Assemble your fabrics. Wilder patterns are a great choice. For this quilt, the firefly-patterned fabric with pink solid is the Unexpected Visitor.

Glow is made with forty-eight 8-inch (20-cm) blocks with four color combinations:

- Color A (brown abstract/white): 17 blocks
- Color B (starry sky/turquoise): 14 blocks
- Color C (checkerboard/gold): 13 blocks
- Color D (firefly/pink): 4 blocks

Make the Rough Blocks

Glow has 10 blocks with 1/4 patterns, 18 blocks with 1/2 patterns, and 20 blocks with 3/4 patterns. Almost 80 percent of the blocks have half or more of patterned fabrics showing. Keep this ratio in mind when you rough cut your patterned fabrics and solids.

Sew the rough blocks together and press the seams open.

Trim Out the Rough Blocks

Trim the blocks with the Cutting Dance (page 149).

Develop the Design

Place the trimmed blocks on your design wall to develop the composition of your quilt. Try different configurations, and switch out extra blocks for more variations.

Assemble Your Quilt Top

When you are happy with your design, sew all the blocks together and rows together.

FINISH YOUR QUILT

Refer to the Finishing Steps section at the back of the book for detailed instructions on completing your quilt.

Make Your Quilt Back

Make your quilt back whole cloth or pieced. Use what you have on hand or seek fabrics to complement or contrast your quilt top design, keeping in mind the fabrics you have available or planned for facings. The final size should be 56 × 72 inches (142 × 183 cm). Press all seams open.

The back of Glow is made with three 2-yard (2-m) lengths of yukata cotton seamed together so the dragonfly wings touch and produce a fabulous graphic pattern. The pieced back was not wide enough, so I added 7-inch- (18-cm-) wide strips of extension fabric to both sides, which are hidden under the facing.

Make and Sew the Quilt Sandwich

Pin baste the quilt sandwich. Stitch-in-the-ditch around the blocks to secure the quilt sandwich. Tailor baste around the perimeter.

Design and Mark Your Hand-Stitching Pattern

Look at your quilt front and back fabrics to inspire your stitching pattern. The hand-stitching on Glow mimics the soaring spirits and spirals of the front patterned fabrics. Size up the forms onto freezer paper and cut them out. Attach the paper patterns to the quilt top with a medium-hot iron or straight pins and trace them with a blue water-soluble marking pen. Position the patterns so as much of the linework as possible crosses the solid-colored fabrics.

Hand Stitch Your Quilt

Hand stitch, following the blue lines, with a high-contrast thread color.

Block and Trim Your Quilt

Block your quilt (see page 179), if you like. Trim your quilt and staystitch the perimeter of the quilt.

Make and Add the End Cap Facings

Refer to End Cap Facings (page 183) for detailed instructions on making and sewing on a facing.

The double-thick facing for Glow is made with 2 yards (2 m) of yukata cotton, two 5 × 72-inch (13 × 183-cm) pieces of extension fabric, and 1½ yards (1.5 m) of a solid. Cut the yukata cotton in half lengthwise, yielding two 7 × 72-inch (18 × 183-cm) pieces. Seam each piece to extension fabric. Before pressing in half lengthwise, trim an 8-inch (20-cm) length of the facing front/extension fabric off each piece.

THE STITCHING PATTERN FOR GLOW, MADE WITH FREEZER PAPER.

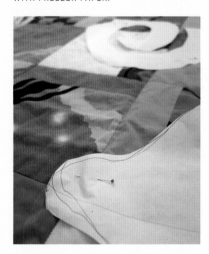

THE HAND-STITCHING PATTERN WAS PINNED INSTEAD OF PRESSED ON WITH AN IRON.

Cut two 10-inch- (25-cm-) wide strips from the long grain of the solid. Seam the 8-inch (20-cm) pieces of the facing front/extension fabric to one end of each solid strip before pressing in half lengthwise. Trim the double-thick facing strips to 4½ inches (11.5 cm) wide.

Position the facing strips, right side down, on the quilt front. Trim the side strips to the exact length of the quilt sandwich. Trim the top and bottom strips 3 inches (7.5 cm) shorter than the quilt width. Place the top and bottom strips on top of the side strips.

Stitch on the strips with a ¼-inch (6-mm) seam allowance and turn to the back for a 4¼-inch- (11.5-cm-) wide finished facing. Note that the sides of the facing overlap the top and bottom so the yukata pattern runs the full length of the quilt. Use thread matching each facing fabric for the invisible stitching.

Final Details

Name your quilt and add a label.

Good Fortune

Stripes as Solids

The towering heads of sunflowers turn to meet the sun, making them a symbol of spiritual attainment in Japan. Also an emblem of good fortune, sunflowers are often given to someone working toward a goal or as a house-warming gift to welcome new opportunities.

Good Fortune shines with only three colors. The patterned fabrics include red, yellow, and indigo on white. Red dominates as the primary solid color, with yellow as the Unexpected Visitor. To get started, pull together your fabric candidates. Keep your choices simple, with a limited palette for your patterns, stripes, and solids. Instead of stripes, consider polka dots or another uncomplicated pattern to replace some of the solids. The hand-stitching pattern, a petal mandala, adds contrast to Good Fortune's striped design. Make the stitching pattern anything that relates to your fabrics—the more curvaceous, the better!

Good Fortune

FINISHED QUILT MEASURES
56 × 56 INCHES (142 × 142 CM)

- **Graphic stripes and stalks of bamboo replace solids in some of the blocks**
- **The two yellow blocks land as the Unexpected Visitor**
- **The hand-stitching pattern mimics the whorl of a sunflower**

MATERIALS

Patterned Fabrics

Four contemporary fabrics (44–45 inches [112–114 cm] wide): minimum ½ yard (46 cm) for the indigo lilies, red flowers, and op-art bands; minimum ¾ yard (69 cm) for the sunflowers OR four yukata cottons (14 inches [35.5 cm] wide): minimum 3 yards (3 m) for the indigo lilies, red flowers, and op-art bands; minimum 4 yards (4 m) for the sunflowers.

Striped Fabrics

Two contemporary fabrics (44–45 inches [112–114 cm] wide): minimum ¾ yard (69 cm) for graphic stripes and bamboo stalks OR two yukata cottons (14 inches [35.5 cm] wide): minimum 2 yards (2 m) for graphic stripes and bamboo stalks.

Solid Fabrics

Two solids (44–45 inches [112–114 cm] wide): minimum ¼ yard (23 cm) for yellow, minimum 1 yard (1 m) for red.

MAKE YOUR QUILT TOP

Refer to the Make Your Quilt Top section at the back of the book for detailed instructions on making your quilt top.

Assemble your fabrics. There are four patterns and two stripes plus two solids. For this quilt, soft yellow is the Unexpected Visitor.

Good Fortune is made with forty-nine 8-inch (20-cm) blocks with five fabric combinations:

- Combo A (sunflower/graphic stripe): 14 blocks
- Combo B (indigo lilies/bamboo stalks): 13 blocks
- Combo C (red flowers/red): 11 blocks
- Combo D (op-art bands/red): 9 blocks
- Combo E (op-art bands/yellow): 2 blocks

Make the Rough Blocks

Good Fortune has 13 blocks with 1/4 patterns, 21 blocks with 1/2 patterns, and 15 blocks with 3/4 patterns. Almost 75 percent of the blocks have half or more of patterned fabrics showing. Keep this ratio in mind when you rough cut your patterned fabrics and solids.

Sew the rough blocks together and press the seams open.

Trim Out the Rough Blocks

Trim the blocks with the Cutting Dance (page 149).

Develop the Design

Place the trimmed blocks on your design wall to develop the composition of your quilt top. Try different configurations, and switch out extra blocks for more variations.

Assemble Your Quilt Top

When you are happy with your design, sew all the blocks and rows together.

FINISH YOUR QUILT

Refer to the Finishing Steps section at the back of the book for detailed instructions on completing your quilt.

Make Your Quilt Back

Make your quilt back whole or pieced. Use what you have on hand or seek fabrics to complement or contrast your quilt top design, keeping in mind the fabrics you have available or planned for the facing. The final size should be 64 × 64 inches (163 × 163 cm). Press all seams open.

The back of Good Fortune combines a 1¾-yard (1.75-m) length of solid red (44–45 inches [112–114 cm] wide) capped with striped yukata cotton. To make a similar back, carefully piece together five 20-inch (51-cm) pieces of the yukata cotton so the striped fabric looks like one long piece. Sew the red fabric and pieced striped fabric together.

Make and Sew the Quilt Sandwich

Pin baste the quilt sandwich. Stitch-in-the-ditch around the blocks to secure the quilt sandwich. Tailor baste around the perimeter.

Design and Mark Your Hand-Stitching Pattern

Look at your quilt front and back fabrics to inspire your stitch pattern. The stunning sunflower fabric of Good Fortune inspired the hand-stitching pattern. A mandala made of overlapping petal shapes creates a circular stitch design.

Make this stitch design with three freezer-paper patterns. To start, overlap two 28-inch (71-cm) lengths of freezer paper by a few inches and weld them together using an iron set to medium-high. Trim the freezer paper to 24 inches (61 cm) square. Draw four straight lines through the center of the square: two diagonally from corner to corner, one up and down, and one from side to side. Trim the 24-inch (61-cm) square into a 24-inch (61-cm) circle.

Identify but do not mark the center of the quilt. Place the center of the freezer paper exactly on top of the center of the quilt and press the circle onto the quilt top. Trace the edge of the freezer-paper circle onto the quilt top with a blue water-soluble marking pen.

WHAT MAKES STRIPES?

Stripes can be parallel bars, bamboo stems, or any other visual element that creates a repeated linear pattern. In Good Fortune, not only do stripes replace solids, one of the patterns also is chock-full of stripes. In exploring ideas for your quilt design, consider combining lots of similar shapes as a graphic device.

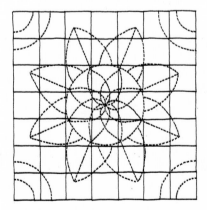

THE STITCHING PATTERN FOR GOOD FORTUNE.

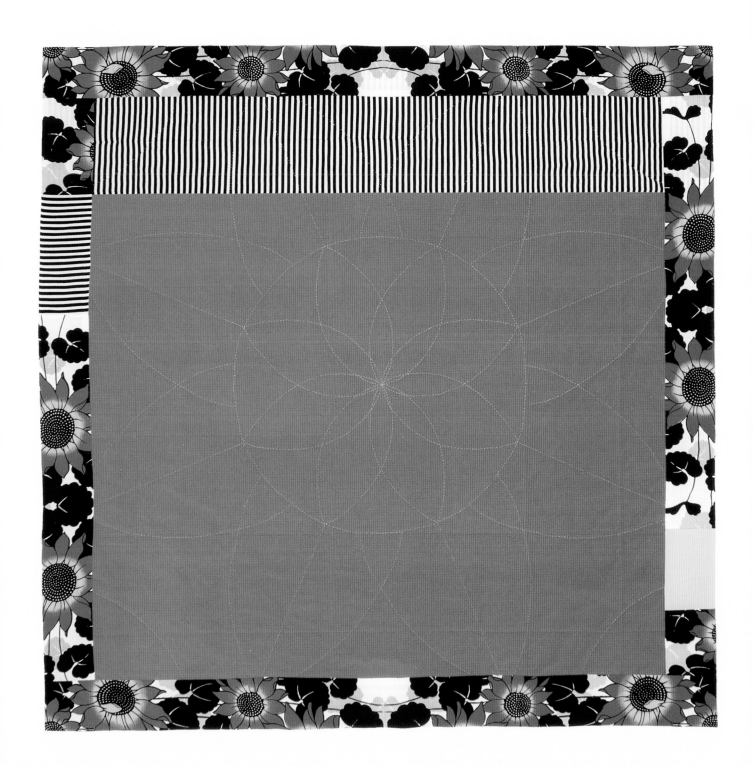

Using a 24-inch (61-cm) grid ruler, extend the eight lines on the freezer paper circle past the edge of the circle, onto the quilt top, with the marking pen. Remove the freezer paper circle.

Using a different piece of freezer paper, draw and cut out a second pattern in a petal shape, 12 × 5¼ inches (30.5 × 13.5 cm) at the widest point. Line up the petal pattern on the quilt top with one tip at the center point of the quilt, and the other tip touching the edge of the circle where a line radiates out. Holding the petal pattern in place, mark the shape. Move the petal pattern around the circle and mark it seven more times.

Take care not to press the petal pattern onto the top. The quilt is already marked with blue linework, and if those first markings are heated, they will be permanently set.

The third freezer-paper pattern is a large half petal. The petal shape is 12¼ inches (31 cm) wide at its base and 14 inches (35.5 cm) high. Line up the base of the half-petal pattern on the edge of the circle with the tip on a radiating line. Holding the half-petal pattern in place, mark the shape. Move the half-petal pattern around the circle and mark seven more times.

Hand stitch, following the blue lines, with a high-contrast thread color.

Block and Trim Your Quilt

Block your quilt (see page 179), if you like. Trim your quilt and staystitch around the perimeter.

Make and Add the End Cap Facing

Refer to End Cap Facings (page 183) for detailed instructions on making and sewing on a facing.

The single-thick facing for Good Fortune is made with 4 yards (4 m) of yukata cotton plus a scrap of 5-inch- (13-cm-) wide striped yukata cotton and a scrap of 5-inch- (13-cm-) wide solid. Cut the yukata cotton into two 2-yard (2-m) lengths. Cut two 5-inch- (13-cm-) wide strips out of each length of yukata cotton to yield four 5-inch- (13-cm-) wide pieces that are 2 yards (2 m) long. Randomly cut across two of the lengths of yukata cotton. To one, seam in the scrap of striped yukata cotton; to the other, seam in the piece of solid. Press all seams open.

Turn under the 5-inch- (13-cm-) wide facing strips ⅝ inch (1.5 cm) along one edge, using an iron.

Position the facing strips, right side down, on the quilt front. Trim the top and bottom strips to the exact width of the quilt sandwich. Trim the side strips 3 inches (7.5 cm) shorter than the quilt length. Place the side strips on top of the top and bottom strips.

Stitch on the strips with a ¼-inch (6-mm) seam allowance and turn to the back for a 4⅛-inch- (10.5-cm-) wide finished facing. Use thread matching each facing fabric for the invisible stitching.

Final Details

Name your quilt and add a label.

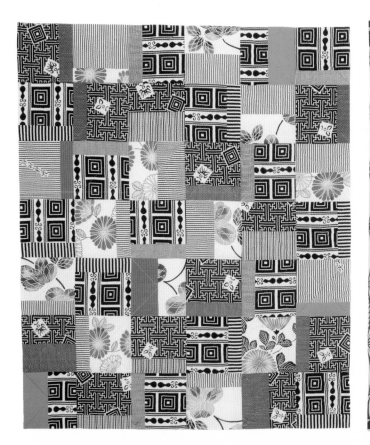

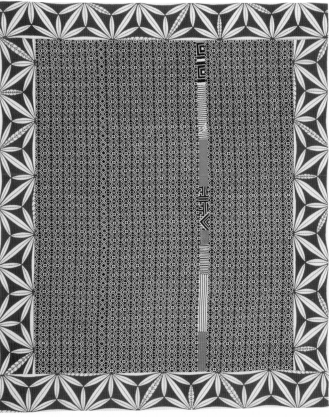

AYAKO

Making-do

FINISHED QUILT
MEASURES
48 × 56 INCHES
(122 × 142 CM)

After the Second World War, Ayako Miyawaki (1905–1995) made a daily practice of stitching together a piece of artwork using found textiles. Ayako's folk art, using only what was available, became famous across Japan and toured internationally.

With limited amounts of floral and striped fabrics on hand, Ayako scrambles its fabric partners in many of the quilt blocks. This approach of making-do upholds the spirit of improvisational quilting. Overall the indigo-and-white yukata cottons—five different widths of stripes and two geometric patterns—create a neutral ground. Two bright floral-on-white fabrics and a few bars of red and turquoise enliven the composition. The Unexpected Visitor quietly slips in as a whole block made with a third floral pattern. Try playing with fabrics in your stash to create your own making-do quilt.

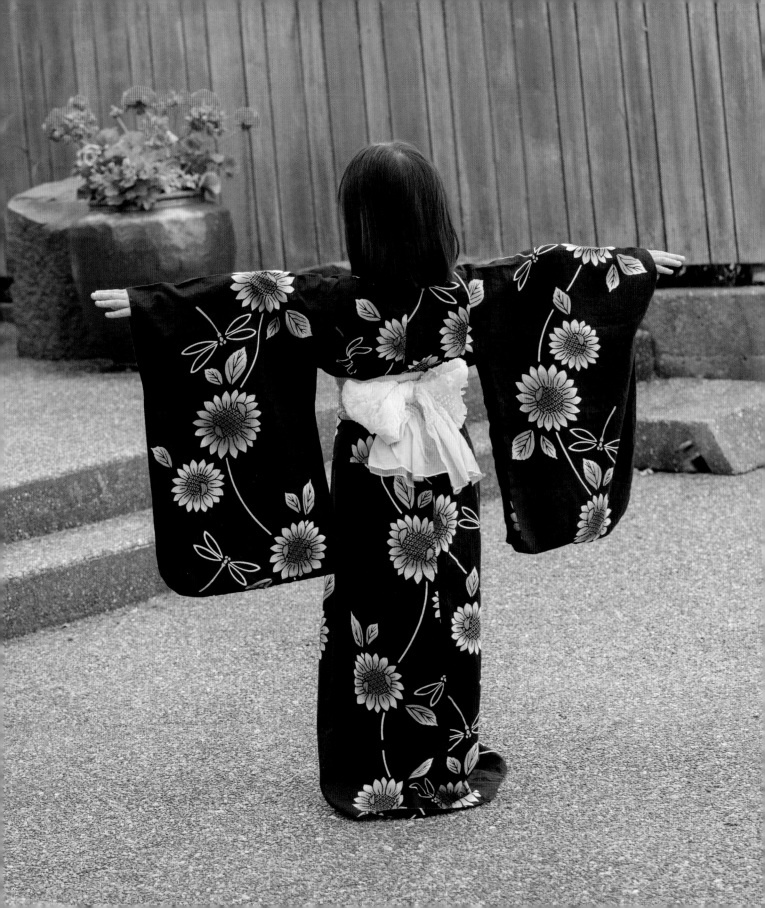

Yukata Cotton Primer

In the eighth century, Japanese noblemen wore unlined cotton kimonos while taking steam baths. These robes, called *yukatabira*, protected them from the steam and were convenient to wear home.

By the 1800s, bathhouses shifted from steam to soaking tubs. These public establishments became wildly popular, with more than five hundred in Edo (modern-day Tokyo) alone. Casual cotton kimonos, now nicknamed *yukata*, were seen on the streets as patrons walked back from the baths.

Fast-forward to today. With few bathhouses left, the Japanese have adopted the yukata as a national dress for summer Obon festivals. Young girls wear the brightest yukatas. Married women don yukatas with muted colors. And men typically sport yukatas with quintessential blue-and-white geometric patterns or solid colors.

Crisp yukata cotton is traditionally *chusen*-dyed. A layer of rice resist is applied using a paper stencil hand-cut with the fabric pattern. Skilled artisans pour vibrant dyes through the prepared cotton before it is washed four times and hung in the sun to dry.

YUKATA FACTOIDS

- *Yukata* translates to "bathing clothes."
- One bolt of yukata cotton makes one yukata.
- One bolt, or *tan*, holds 12 to 13 yards (11.5–12 m) of cotton.
- Yukata cotton measures approximately 14 inches (35.5 cm) wide.

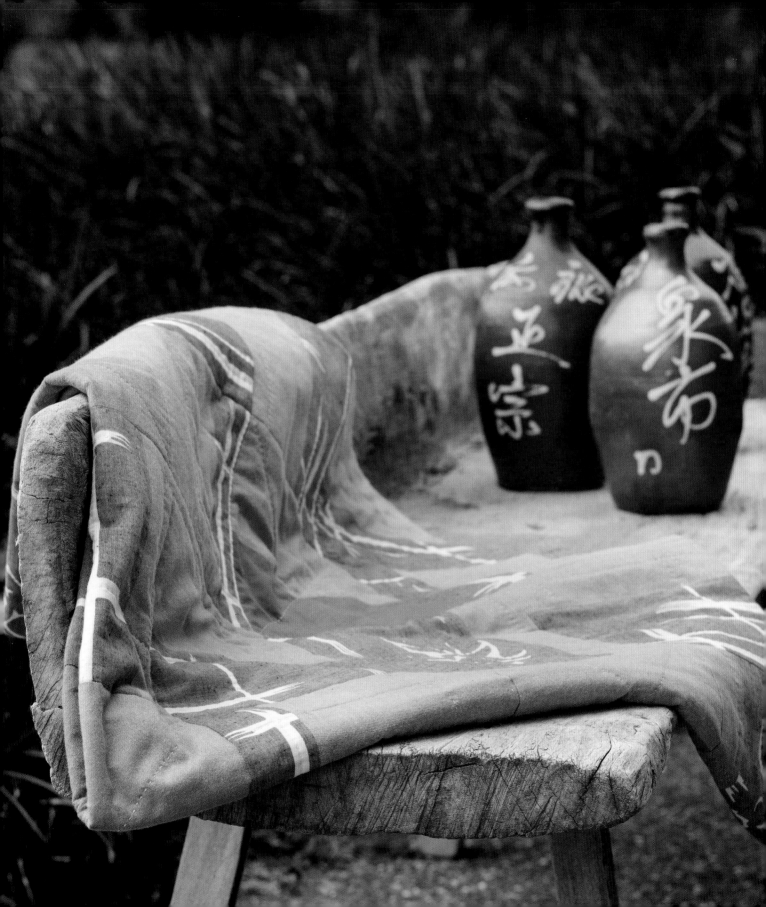

Kabuki

Adding Structural Elements

Kabuki, a classical Japanese dance-drama, was first performed in 1603 by a shrine maiden in a dry riverbed of Kyoto. The dramatic style became popular, first with all-women troupes and later with men playing the male and female roles.

Opposing elements come together in the layout of Kabuki. The main blocks, with their changing widths and rotations, create a spontaneous arrangement. At the same time, the two-color blocks interject structure into the composition. An important aspect of this quilt design is the sameness of the colors: They are all similar in value, and the low-key contrast results in a quiet design. Yet look at how special the fabrics are. The blue yukata cotton with the kabuki faces is hand-woven and hand-dyed, and the solids are two-tone shot cottons. Kabuki shows you how to make an engaging quilt using minimal patterns and colors. Sometimes less gives you more creative freedom.

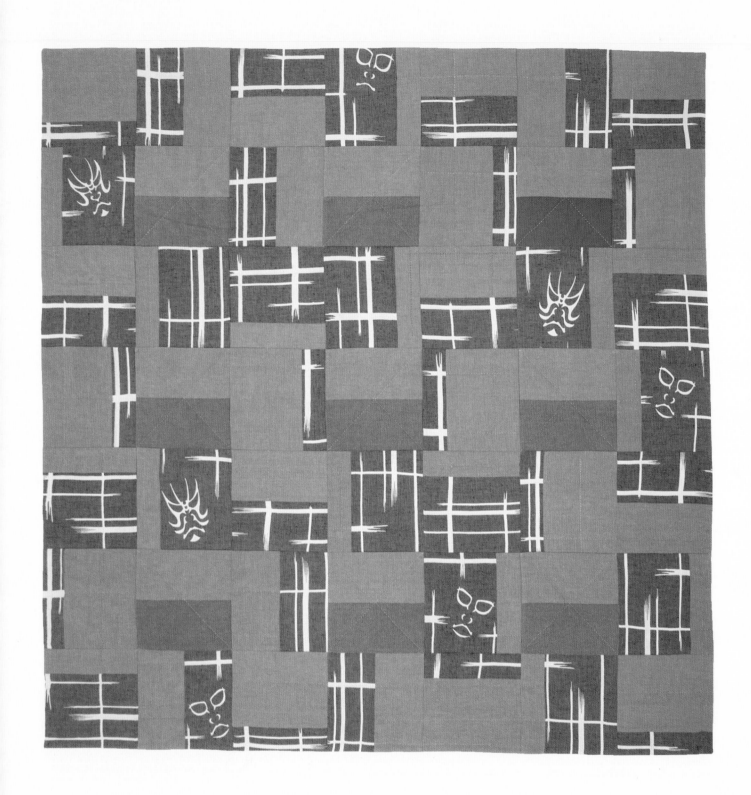

Kabuki

FINISHED QUILT MEASURES
56 × 56 INCHES (142 × 142 CM)

- - - - - - - - - - - - - - -

- **Blocks with two solids colors punctuate the quilt top**
- **The gray solid appears in every block**
- **The Unexpected Visitor, the avocado solid, is positioned at the heart of the design**

- - - - - - - - - - - - - - -

MATERIALS

Patterned Fabrics

One contemporary fabric (44–45 inches [112–114 cm] wide): minimum 2½ yards (2.5 m) of blue patterned fabric OR one yukata cotton (14 inches [35.5 cm] wide): minimum 7 yards (7 m) of the blue patterned fabric.

Solid Fabrics

Three solids (44–45 inches [112–114 cm] wide): 5 × 9-inch (13 × 23-cm) scrap of avocado, minimum ¼ yard (23 cm) for the ginger, and minimum 2½ yards (2.3 m) for gray.

MAKE THE QUILT TOP

Refer to the Make Your Quilt Top section at the back of the book for detailed instructions on making your quilt top.

Assemble your fabrics. Look for low-contrast within your palette. For this quilt, the avocado solid is the Unexpected Visitor.

Kabuki is made with forty-nine 8-inch (20-cm) blocks with three color combinations:

- Color A (blue pattern/gray): 40 blocks
- Color B (gray/ginger): 8 blocks
- Color C (gray/avocado): 1 block

Make the Rough Blocks

Of the 40 blue pattern/gray blocks, Kabuki has 11 blocks with 1/4 patterns, 13 blocks with 1/2 patterns, and 16 blocks with 3/4 patterns. This almost equal amount of each block combination contributes to the quilt's understated appearance. Keep this ratio in mind when you rough cut your patterned fabrics and solids.

Sew the rough blocks together and press the seams open.

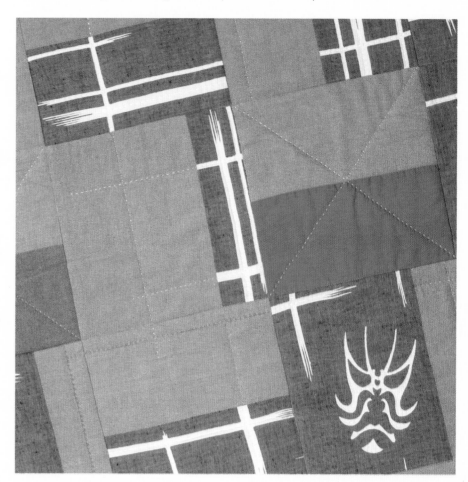

Trim Out the Rough Blocks

Trim the blocks with the Cutting Dance (page 149).

Develop the Design

Place the trimmed blocks on your design wall to develop the composition of your quilt top. Try different configurations, and switch out extra blocks for more variations.

Assemble Your Quilt Top

When you are happy with your design, sew all the blocks and rows together.

- -

FINISH YOUR QUILT

Refer to the Finishing Steps section at the back of the book for detailed instructions on completing your quilt.

Make Your Quilt Back

Make your quilt back whole cloth or pieced. Use what you have on hand or seek fabrics to complement or contrast your quilt top design, keeping in mind the fabrics you have available or planned for the facing. The final size should be 64 × 64 inches (163 × 163 cm). Press all seams open.

The back of Kabuki is made with a handsome kasuri-woven kimono presented to my husband, Michael, by good friends in Tokyo. I carefully took apart the hand-stitched vintage silk kimono to yield almost 12 yards (12 m) of flat fabric. I pieced together the woven cloth with scrap pieces of the gray and ginger shot cottons used in the quilt front.

Make and Sew the Quilt Sandwich

Pin baste the quilt sandwich. Stitch-in-the-ditch around the blocks to secure the quilt sandwich. Tailor baste around the perimeter.

Design and Mark Your Hand-Stitching Pattern

Look at your quilt front and back fabrics to inspire your stitching pattern. On Kabuki, I marked stitch lines diagonally across the two-color blocks and randomly throughout the gray solid using a grid ruler and a blue water-soluble marking pen. Freestyle stitching inside the white lines of the blue pattern fabric completed the stitch design.

Hand Stitch Your Quilt

Hand stitch, following the blue lines and the patterns within the fabric.

Block and Trim Your Quilt

Block your quilt (see page 179), if you like. Trim your quilt and staystitch the perimeter of the quilt.

Make and Add the End Cap Facing

Refer to End Cap Facings (page 183) for detailed instructions on making and sewing on a facing.

EARLY DESIGN ITERATION OF KABUKI WITH NO TWO-COLOR BLOCKS.

The double-thick facing for Kabuki is made with 1½ yards (1.5 m) of ginger shot cotton and scraps of the blue patterned fabric. Cut the ginger shot cotton into four 4 × 54-inch (10 × 137-cm) strips along the long grain and seam to 4 × 10-inch (10 × 25-cm) pieces of the blue patterned fabric along the short sides. Press the shot cotton/patterned strips in half lengthwise. Trim the strips to 2⅜ inches (6 cm) wide and 55 inches (140 cm) long.

Position the facing strips, right side down, on the quilt front. Pin one end of each strip flush with the edge of the quilt sandwich. Place the other end on top of the next strip, pinwheel-style.

Stitch on the strips with a ¼-inch (6-mm) seam allowance and turn to the back for a 2⅛-inch- (5.5-cm-) wide finished facing. Note the fussy cutting of the blue patterned fabric in the corners to show a peek of the kabuki faces. Use thread matching each facing fabric for the invisible stitching.

Final Details
Name your quilt and add a label.

The Art of Flowers

Pinstripes

A disciplined art form in Japan, ikebana translates as "living flowers." Each floral composition, made with a minimal number of blooms in a specially chosen vessel, is arranged to look alive and growing.

High-contrast pinstripes separate five floral patterns from their coordinated solids in The Art of Flowers. The audacious color combinations evoke real-world gardens and gaudy detailing on hot rods. The original concept for this quilt design included many morning glory blocks. Although you could assume that anything works in this garish design, the gold paired with turquoise did not fit in. Just one morning glory block remains as the Unexpected Visitor. Be sure to test the width of your pinstripes. If they are too narrow, the shadows of the two neighboring fabrics can make them invisible. If too wide, they lose their edginess as chichi pinstripes.

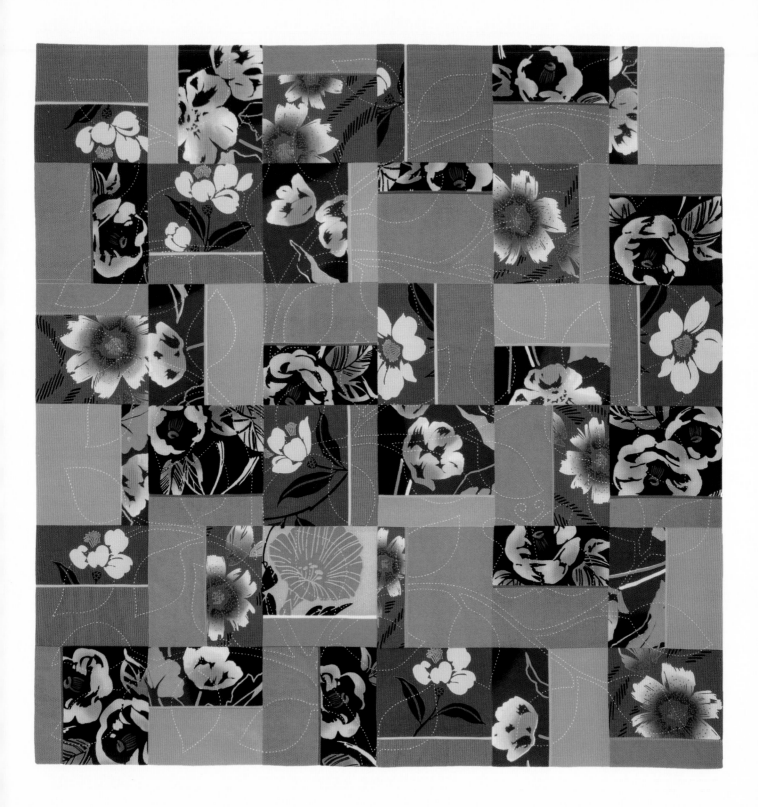

The Art of Flowers

FINISHED QUILT MEASURES
48 × 48 INCHES (122 × 122 CM)

- Flashy pinstripes race through each block
- The morning glory and turquoise block radiates as the Unexpected Visitor
- The stitch pattern of leaves on arching branches extends the flora theme

MATERIALS

Patterned Fabrics

Five contemporary fabrics (44–45 inches [112–114 cm] wide): minimum ¼ yard (23 cm) for two floral patterns; minimum ½ yard (46 cm) for three floral patterns OR five yukata cottons (14 inches [35.5 cm] wide): minimum 1 yard (1 m) for one floral pattern; minimum 2 yards (2 m) for two floral patterns; minimum 3 yards (3 m) for two floral patterns.

Pinstripe Fabrics

Five contrasting solids: minimum 9 × 10-inch (23 × 25-cm) scrap pieces for the pinstripes.

Solid Fabrics

Five solids (44–45 inches [112–114 cm] wide): minimum 5 × 9-inch (13 × 23-cm) scrap for the turquoise; minimum ½ yard (46 cm) for the orange, khaki, plum, and violet.

MAKE THE QUILT TOP

Refer to the Make Your Quilt Top section at the back of the book for detailed instructions on making your quilt top.

Assemble your fabrics. Look for solids that relate to the patterned fabrics and bright, high-contrast colors for the pinstripes. For this quilt, the morning glory block with the turquoise solid and white pinstripe is the Unexpected Visitor.

The Art of Flowers is made with thirty-six 8-inch (20-cm) blocks with five color combinations:

- Color A (orange flowers/turquoise pinstripe/orange): 10 blocks
- Color B (khaki flowers/magenta pinstripe/khaki): 10 blocks
- Color C (peach flowers/tangerine pinstripe/plum): 8 blocks
- Color D (purple-white flowers/persimmon pinstripe/violet): 7 blocks
- Color E (turquoise morning glory/white pinstripe/turquoise): 1 block

Make the Rough Blocks with the Pinstripes

The Art of Flowers has 5 blocks with 1/4 patterns, 15 blocks with 1/2 patterns, and 16 blocks with 3/4 patterns. More than 85 percent of the blocks have the larger amount of patterns. Keep this ratio in mind when you rough cut your patterned fabrics and solids.

Precision cut pinstripes to ¾ × 9-inch (2 × 23-cm) strips. Sew the pinstripes, right sides together, to the patterned and solid fabrics of each block. Press the seam allowances out.

Trim Out the Rough Blocks

Trim the blocks with the Cutting Dance (page 149). Position the desired ruler marking down the middle of each pinstripe.

Develop the Design

Place the trimmed blocks on your design wall to develop the composition of your quilt top. Try different configurations, and switch out extra blocks for more variations.

Assemble Your Quilt Top

When you are happy with your design, sew all the blocks and rows together.

FINISH YOUR QUILT

Refer to the Finishing Steps section at the back of the book for detailed instructions on completing your quilt.

Make Your Quilt Back

Make your quilt back whole cloth or pieced. Use what you have on hand or seek fabrics to complement or contrast your quilt top design, keeping in mind the fabrics you have available or planned for the facing. The final size should be 56 × 56 inches (142 × 142 cm). Press all seams open.

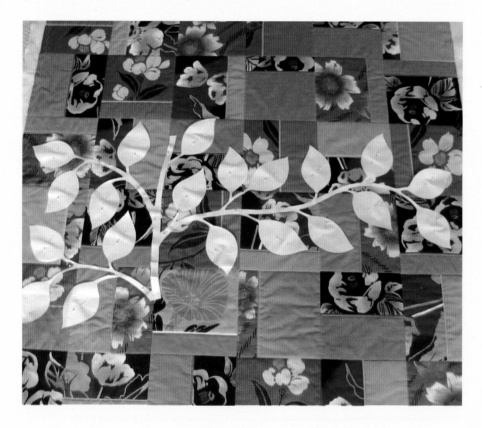

WHAT IS THE BEST BLOCK TO PUT UP FIRST?

Don't worry about which block to put on your design wall first—just get something up there. Then start resolving your design.

For The Art of Flowers, you do not need to explore every possible permutation of your 36 blocks. Work with the spontaneous composition you created and move some blocks around. Also try switching out some of your original blocks with extras. Your goal is to please yourself. You will know what you like when you see it.

AS THE STITCHING PATTERN FOR THE ART OF FLOWERS WAS FRAGILE, IT WAS APPLED IN THREE PIECES.

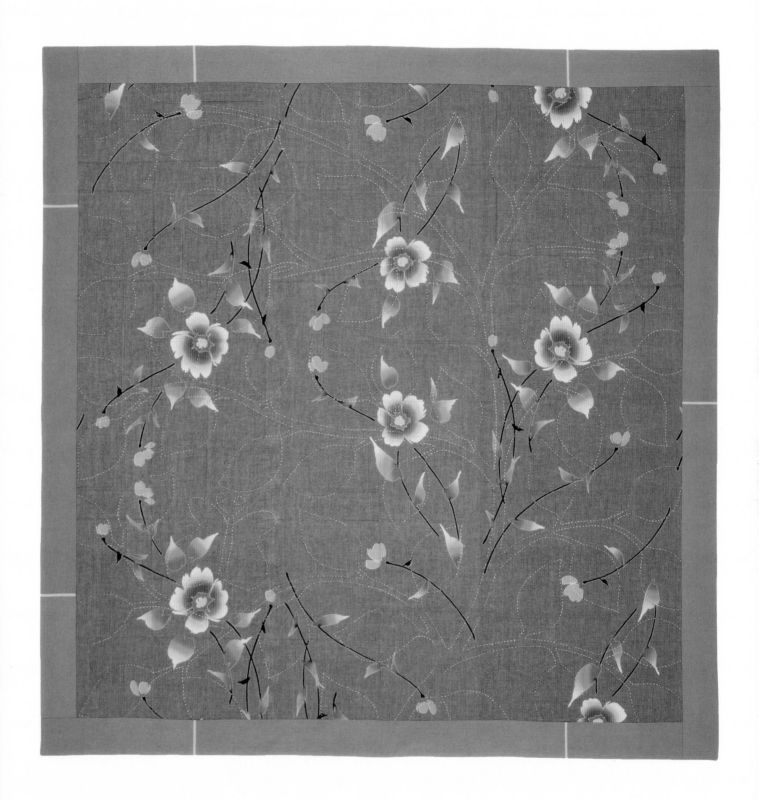

The back of The Art of Flowers is made with 5 yards (5 m) of yukata cotton. The yukata cotton was cut into three equal lengths and sewn together to span the height of the quilt back, with 7 × 56 inches (18 × 142 cm) of extension fabric added to each side.

Make and Sew the Quilt Sandwich

Pin baste the quilt sandwich. Stitch-in-the-ditch around the blocks to secure the quilt sandwich. Stitch-in-the-ditch in the pinstripes, with matching threads, for an optional finishing detail. Tailor baste around the perimeter.

Design and Mark Your Hand-Stitching Pattern

Look at your quilt front and back fabrics to inspire your stitching pattern. The hand-stitching pattern of The Art of Flowers, eight branches with sixty leaves and one butterfly, relates to the garden motif of the patterned fabrics. Overlap three 50-inch (127-cm) lengths of freezer paper by a few inches and weld together with an iron set to medium-high. Draw the pattern on the freezer paper, then cut it out with sharp paper scissors. The paper pattern is delicate, so cut it into manageable pieces before ironing onto the quilt top. Iron all the stitching patterns onto the quilt top and trace around the edges with a blue water-soluble marking pen.

Hand Stitch Your Quilt

Hand stitch, following the blue lines with a high-contrast thread.

Block and Trim Your Quilt

Block your quilt (see page 179), if you like. Trim your quilt and staystitch the perimeter of the quilt.

Make and Add the End Cap Facing

Refer to End Cap Facings (page 183) for detailed instructions on making and sewing on a facing.

The double-thick facing for The Art of Flowers is made with ¾ yard (69 cm) of the violet solid and a 7 × 7-inch (18 × 18-cm) scrap piece of the tangerine solid. Cut the violet solid into eight 7 × 27-inch (18 × 69-cm) strips along the grain. Then cut three of the violets strips in half to make six 7 × 13½-inch (18 × 34-cm) strips. Cut the tangerine solid into seven ¾ × 7-inch (2 × 18-cm) strips. Sew the tangerine strips to the violet strips to make 50-inch- (127-cm-) long facing pieces with one or two pinstripes per side. Press the facing strips down the center and trim to 2½ × 47 inches (6 × 119.4cm).

Position the facing strips, right side down, on the quilt front. Place one end of each strip flush with the edge of the quilt sandwich. At corners, place the short end of each facing strip on the top side of the next strip to create a pinwheel-style look.

Stitch on the strips with a ¼-inch (6-mm) seam allowance and turn to the back for a 2¼-inch- (6-cm-) wide finished facing. Use thread matching the facing fabric for the invisible stitching.

Final Details

Name your quilt and add a label.

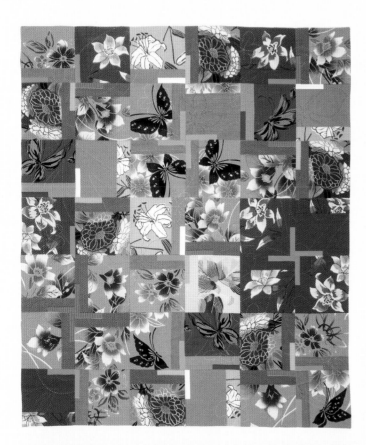

PINWHEELS

Bars of bright colors

FINISHED QUILT
MEASURES
48 × 56 INCHES
(122 × 142 CM)

Every May, tall poles laden with carp banners and topped with colorful pinwheels celebrate Children's Day in Japan. Pinwheels, filled with youthful innocence and energy, also symbolize the power to turn one's luck around.

Pinwheels combines seven floral patterns with seven dull solids and seven bright color bars. With so many graphic elements, the pinwheel placement of the color bars unifies the quilt design. The loner color bars that aren't grouped add a visual twist.

The ¾ × 4-inch (2 × 10-cm) bright bars required precision cutting and sewing. Each solid element had to be made the exact width, with consideration for seam allowances, before sewing to the floral fabrics.

The double-thick end cap facing was made with extremely narrow strips, perhaps not the ideal width for a facing. The result may be a little bulky, so I suggest pressing the facing with steam, then using a tailor's clapper to flatten the edge. The finished facing width is ¾ inch (2 cm).

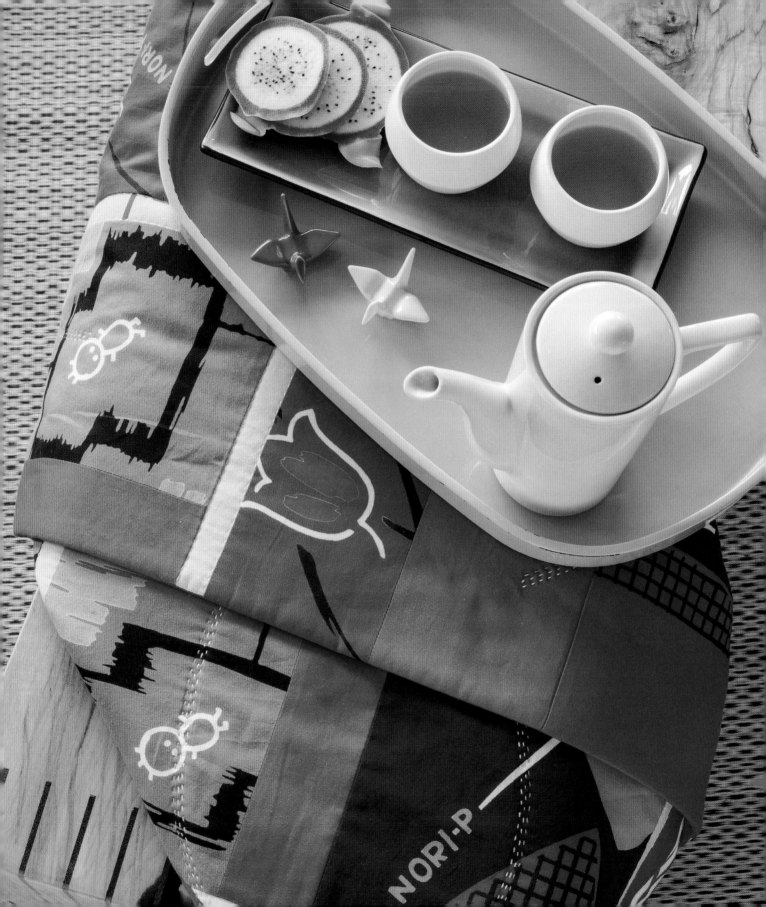

Nori-P

Unifying with Sashing

Teenage pop singer Nori-P (Noriko Sakai) exploded onto the Japanese music scene in 1986. At that time, many novelty yukata cotton designs featured her autograph—a cartoonish little man with three hairs on his head.

The sashing takes center stage in Nori-P. The ¾-inch- (2-cm-) wide yellow sashing stands out from the quilt blocks with its bright color and particularly narrow width. If the sashing was a typical 2- or 3-inch (5–7.5-cm) width, it would compete visually with the piecing in the blocks. Also note the red micro connectors in the sashing. If you have only short fabric pieces for the sashing, you will need to sew strips together. Why hide those seams? Instead, add connectors made with an accent color. Add a few extra connectors as a design element. Then notice how the connectors catch the attention of other quilters.

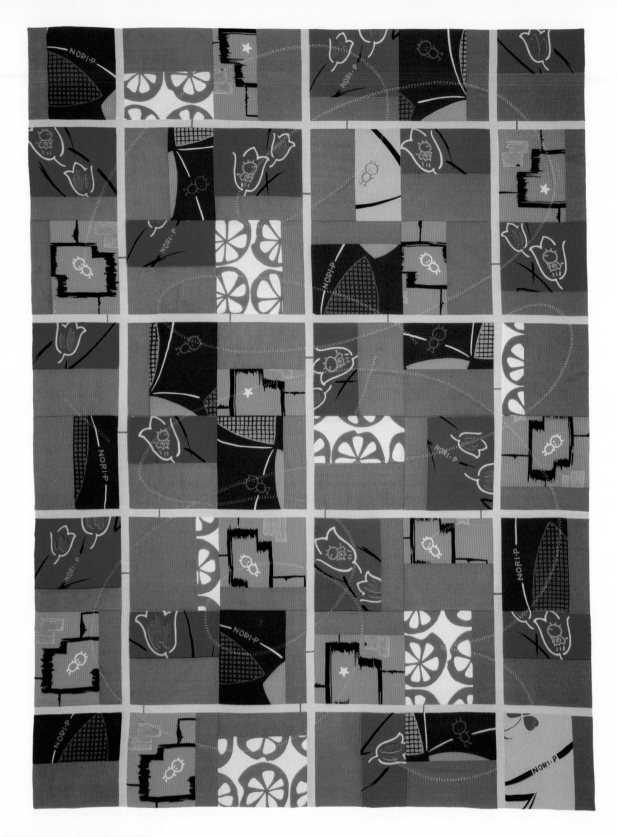

Nori-P

- - - - - - - - - - - - - - - - -

- **Narrow yellow sashing adds a graphic framework**
- **Fire-engine red, included in every block, dominates**
- **The two yellow Nori-P blocks break out as the Unexpected Visitor**

- - - - - - - - - - - - - - - - -

MATERIALS

Patterned Fabrics

Five contemporary fabrics (44–45 inches [112–114 cm] wide): minimum 9 × 12-inch (23 × 30.5-cm) scrap for the yellow pattern, minimum ¼ yard (23 cm) for the tomato pattern, minimum ½ yard (46 cm) for the pink and navy patterns, and minimum ¾ yard (69 cm) for the royal blue pattern OR five yukata cottons (14 inches [35.5 cm] wide): minimum 1 yard (1 m) for the yellow pattern, minimum 2 yards (2 m) for the tomato pattern, minimum 3 yards (3 m) for the pink and navy patterns, and minimum 4 yards (4 m) for the royal blue pattern.

Solid Fabrics

Two solids (44–45 inches [112–114 cm] wide): minimum ½ yard (46 cm) for the yellow, and minimum 2 yards (1.8 m) for the red.

MAKE THE QUILT TOP

Refer to the Make Your Quilt Top section at the back of the book for detailed instructions on making your quilt top.

Assemble your fabrics. Look for one solid color to use as the main color for the quilt. For this quilt, the main color is red. The yellow pattern is the Unexpected Visitor.

Nori-P is made with forty-eight 8-inch (20-cm) blocks with five color combinations:

- Color A (royal blue pattern/red): 16 blocks
- Color B (navy pattern/red): 12 blocks
- Color C (pink pattern/red): 11 blocks
- Color D (tomato pattern/red): 7 blocks
- Color E (yellow pattern/red): 2 blocks

Make the Rough Blocks

Nori-P has 2 blocks with 1/4 patterns, 21 blocks with 1/2 patterns, and 25 blocks with 3/4 patterns. Almost all the blocks have the larger amount of patterns. Keep this in mind when you rough cut your patterned fabrics and solids.

Sew the rough blocks together and press the seams open.

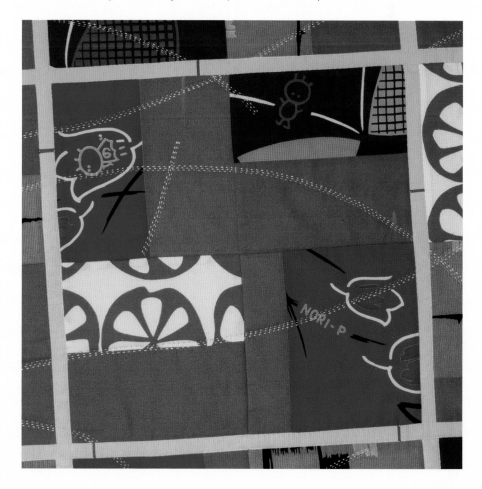

Trim Out the Rough Blocks

Trim the blocks with the Cutting Dance (page 149).

Develop the Design

Place the trimmed blocks on your design wall to develop the composition of your quilt top. Try different configurations, and switch out extra blocks for more variations.

Make Your Sashing

Test short ¾-inch- (2-cm) wide strips of different colors with your quilt top blocks to discern the best color choice for your sashing. Once you are satisfied with your choice, make 1¼-inch- (3-cm-) wide sashing strips with contrasting micro connectors. You need four 50-inch (127-cm) strips for the horizontal sashing, and nine 18-inch (46-cm) strips and six 9-inch (23-cm) strips for the vertical sashing.

Assemble Your Quilt Top

When you are happy with your design, number each row and set of blocks within the sashing. Make a map of your numbering system to refer to when assembling your quilt top.

Sew Row 1 and Row 8 with the 9-inch (23-cm) strips of vertical sashing after every odd-numbered block. Press out the seam allowances of the sashing.

For the vertical row of blocks on the left-hand side, sew together the three pairs of stacked blocks with a horizontal seam. Then sew 18-inch (46-cm) sashing strips on the right side of each set of stacked blocks, with the extra length of sashing strips hanging past the top and bottom. Press the seam allowances of the sashing out. Trim the sashing strips flush with the top and bottom of the stacked blocks.

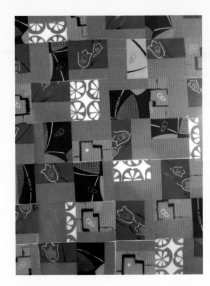

EARLY DESIGN LAYOUT FOR NORI-P WITHOUT SASHING.

NORI-P QUILT ASSEMBLY. ADD VERTICAL SASHING FIRST AND THEN HORIZONTAL SASHING.

Sew the interior four-patch squares together. Sew the top two blocks first and the lower two blocks second. Sew the horizontal seams between the two sets of blocks. Then sew 18-inch (46-cm) sashing strips on the right side of each four-patch, with the extra length of the sashing strips hanging past the top and bottom. Press the seam allowances of the sashing out. Trim the sashing strips flush with the top and bottom of each four-patch.

For the vertical row of blocks on the right-hand side, sew together the three pairs of stacked blocks with a horizontal seam.

Sew all the blocks and sashing of Rows 2/3 together, from left to right. Repeat for Rows 4/5 and Rows 6/7. Press the seam allowances for the sashing out.

Sew on a 50-inch (127-cm) sashing strip to the bottom of Row 1, Rows 2/3, Rows 4/5, and Rows 6/7. Press the seam allowance of the sashing out.

Sew the top of Row 2/3 to the bottom edge of Row 1's sashing, lining up the vertical sashing. Continue for Rows 4/5, Rows 6/7, and Row 8. Press the seam allowances of the sashing out.

- -

FINISH YOUR QUILT

Refer to the Finishing Steps section at the back of the book for detailed instructions on completing your quilt.

Make Your Quilt Back

Make your quilt back whole cloth or pieced. Use what you have on hand or seek fabrics to complement or contrast your quilt top design, keeping in mind the fabrics you have available or planned for the facing. The final size should be 58 × 75 inches (147 × 190.5 cm). Press all seams open.

The back of Nori-P is made with three different yukata cottons: 2 yards (2 m) each of the pink and royal blue pattern, and 4 yards (4 m) of the navy pattern. Cut all the yukata cottons into 1-yard (1-m) pieces and sew them together lengthwise to make large pieces of fabric. Position the royal blue off-center to create an asymmetric layout. Add extra strips of extension fabric to the sides and the bottom, as needed, to make a large enough back. Remember that narrow widths of extension fabric will be covered with end cap facings.

Make and Sew the Quilt Sandwich

Pin baste the quilt sandwich. Stitch-in-the-ditch around the blocks to secure the quilt sandwich. Tailor baste around the perimeter.

Design and Mark Your Hand-Stitching Pattern

Look at your quilt front and back fabrics to inspire your stitching pattern. The hand-stitching pattern on Nori-P is a riff on the pop star's signature, found in a vintage CD booklet. To make a similar pattern, overlap four 72-inch (183-cm) lengths of freezer paper by a few inches and weld them together with an iron set to medium-high. Scale up the signature on the large piece of freezer paper. Cut out the needed areas to reveal

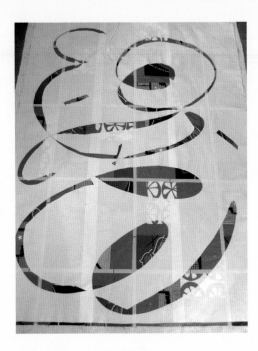

the stitching linework with sharp paper scissors. To keep the pattern from falling apart, leave strategically placed paper bridges in the stitching pattern.

Iron your stitching pattern onto the quilt top and trace around the edges with a water-soluble blue marking pen.

Hand Stitch Your Quilt

Hand stitch, following the blue lines. Echo stitch around the first line of stitching two times to create an impact on the patterned fabrics.

Hand-stitch-in-the-ditch along both sides of the sashing of Nori-P with matching perle cotton thread for an added finishing touch.

Block and Trim Your Quilt

Block your quilt (see page 179), if you like. Trim your quilt and staystitch the perimeter of the quilt.

Make and Add the End Cap Facing

Refer to End Cap Facings (page 183) for detailed instructions on making and sewing on a facing.

The double-thick facing for Nori-P is made with ¾ yard (69 cm) of pink and red plus a 10 × 7-inch (25 × 18-cm) scrap of yellow. Cut the yellow into eleven ¾ × 7-inch (2 × 18-cm) pieces. Cut the pink and red into 7 × 27-inch (18 × 69-cm) strips along the long grain. Randomly cut the long strips of red and pink into shorter lengths, then sew them back together with the yellow pieces added as connectors to create two 68-inch (173-cm) facing strips and two 51-inch (129.5-cm) facing strips. Press the strips in half lengthwise and trim to 2¾ inches (7 cm) wide.

Position the facing strips, right side down, on the quilt front. Trim the top and bottom strips to the exact width of the quilt sandwich. Trim the side strips 2 inches (5 cm) shorter than the quilt length. Place the side strips on top of the top and bottom strips.

Stitch on the strips with a ¼-inch (6-mm) seam allowance and turn to the back for a 2½-inch- (6-cm-) wide finished facing. Use thread matching each facing fabric for the invisible stitching.

Final Details

Name your quilt and add a label.

(TOP) THE STITCHING PATTERN FOR NORI-P, MADE WITH FREEZER PAPER.

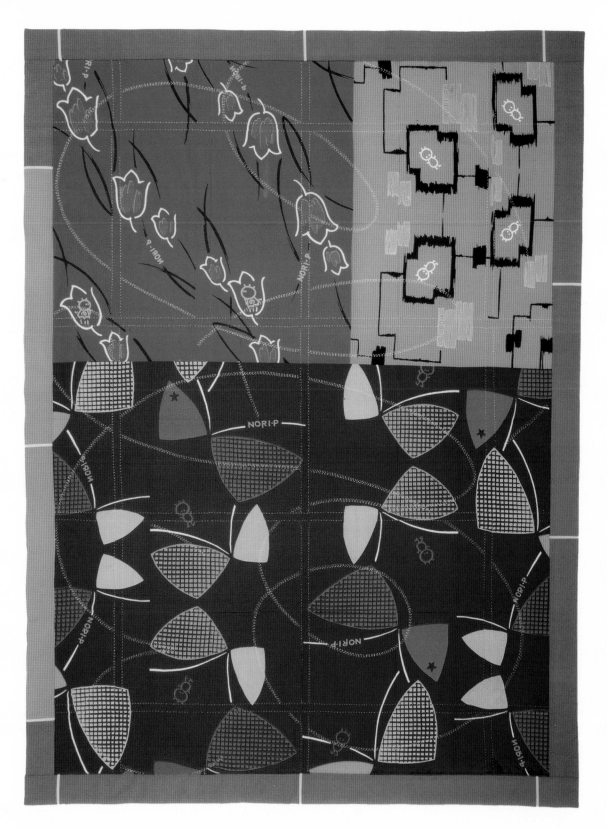

Hidden Wonders

Lyrical Grid

Off the beaten path, you can encounter many strange attractions in Japan. How about the Parasite Museum, an island inhabited by cats, a town with more life-size dolls than residents, and a nightclub made totally of ice?

Hidden Wonders garners attention with its bright micro inset stripes and oversize florals. Two similar indigo yukata cottons create a monochromatic backdrop for these upbeat details. You need to manage your patterns for this iteration. Ideally you want all three patterned fabrics to share the same background color, with one changing scale dramatically. You also need to finesse the colored stripes for your palette and patterns. Make a few sample blocks—inserting a range of narrow and wider stripes—to test for your perfect stripe width. Also confirm the best stripe color, checking the contrast from a distance and in dim light.

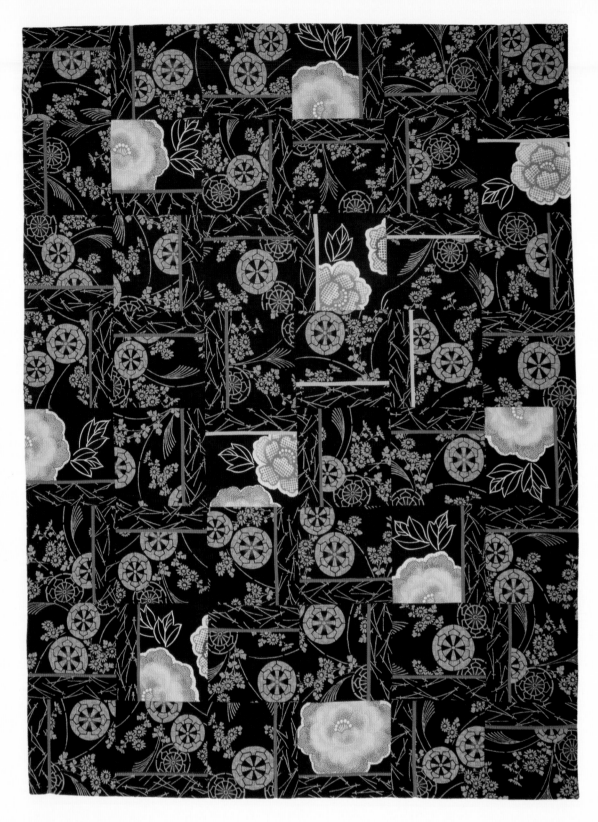

Hidden Wonders

FINISHED QUILT MEASURES
48 × 64 INCHES (122 × 163 CM)

- - - - - - - - - - - - - -

- **Every block configuration is a 3/4 pattern paired with a 1/4 pattern**
- **Colored micro inserts separate the two block elements**
- **Six yellow lines infiltrate the grid as the Unexpected Visitor**

- - - - - - - - - - - - - -

MATERIALS

Patterned Fabrics

Three contemporary fabrics (44–45 inches [112–114 cm] wide): minimum ½ yard (46 cm) for the mega flower pattern, minimum 1 yard (1 m) for the pine needle pattern, and minimum 2 yards (2 m) for the ox cart wheel pattern OR three yukata cottons (14 inches [35.5 cm] wide): minimum 3 yards (3 m) for the mega flower pattern, minimum 4 yards (4 m) for the pine needle pattern, and minimum 7 yards (7 m) for the ox cart wheel pattern.

Solid Fabrics

Two solid fabrics (44–45 inches [112–114 cm] wide): minimum ¼ yard (23 cm) for the yellow and red.

MAKE THE QUILT TOP

Refer to the Make Your Quilt Top section at the back of the book for detailed instructions on making your quilt top.

Assemble your fabrics. Look for patterned fabrics that share the same background color. Choose stripe colors that contrast with the patterned fabrics. For this quilt, the yellow stripes are the Unexpected Visitor.

Hidden Wonder is made with forty-eight 8-inch (20-cm) blocks with four color combinations:

- Color A (ox cart wheel/pin needle/red stripe): 35 blocks
- Color B (ox cart wheel/mega flower/red stripe): 7 blocks
- Color C (ox cart wheel/pine needle/yellow stripe): 3 blocks
- Color D (ox cart wheel/mega flower/yellow stripe): 3 blocks

Make the Rough Blocks with Inset Stripes

All 48 blocks of Hidden Wonders pair 3/4 pattern with 1/4 pattern, instead of a solid. The 1/4 pattern is always common—the pine needle fabric. Keep this in mind when you rough cut your patterned fabrics.

Rough Cut Your Patterned Fabrics

Across the width of the yellow and red, cut a 9 × 44-inch (23 × 112-cm) piece. Precision cut ¾ × 9-inch (2 × 23-cm) strips for inset stripes, 42 for red and 6 for yellow.

With right sides together, sew the inset stripes between the two patterned fabrics of each block. To ensure the inset stripes stay an equal width along their lengths, keep them on top of the fabrics as you sew. Press the seam allowances out.

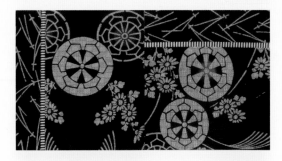

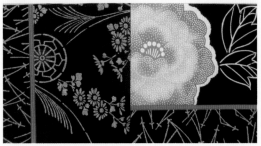

Trim Out the Rough Blocks

Trim the blocks with the Cutting Dance (page 149).

Position the 2¼-inch (6-cm) ruler line on the seam shared by the 3/4 pattern and colored inset stripe.

Develop the Design

Place the trimmed blocks on your design wall to develop the composition of your quilt top. Try different configurations, and switch out extra blocks for more variations.

Assemble Your Quilt Top

When you are happy with your design, sew all the blocks and rows together.

- -

FINISH YOUR QUILT

Refer to the Finishing Steps section at the back of the book for detailed instructions on completing your quilt.

Make Your Quilt Back

Make your quilt back whole cloth or pieced. Use what you have on hand or seek fabrics to complement or contrast your quilt top design, keeping in mind the fabrics you have available or planned for the facing. The final size should be 54 × 72 inches (137 × 183 cm). Press all seams open.

The back of Hidden Wonders is made with 8 yards (8 m) of yukata cotton, cut into four 2-yard (2-m) lengths. Cut one length of yukata cotton down the middle to yield two 7-inch × 2-yard (18-cm × 2-m) pieces. Sew together the three full-width lengths and then sew the 7-inch (18-cm) pieces onto each side.

(TOP) TEST DIFFERENT INSET STRIPES.

Make and Sew the Quilt Sandwich

Pin baste the quilt sandwich. Stitch-in-the-ditch around the blocks to secure the quilt sandwich. Stitch-in-the-ditch in the yellow and red inset stripes, with matching threads, for an optional finishing detail. Tailor baste around the perimeter.

Design Your Hand-Stitching Pattern

With the inset stripes of Hidden Wonders as the design focus, the hand stitching is a secondary detail. The hand stitching echoes the mega blossoms in red, blue, or green thread to match each flower's color.

Hand Stitch Your Quilt

Hand stitch, following the shapes of the mega blossoms.

Block and Trim Your Quilt

Block your quilt (see page 179), if you like. Trim your quilt and staystitch the perimeter of the quilt.

Make and Add the End Cap Facing

Refer to End Cap Facings (page 183) for detailed instructions on making and sewing on a facing.

The double-thick facing for Hidden Wonders is made with 2 yards (2 m) of yukata cotton plus 1¾ yards (1.75 m) of bright blue solid. Cut the yukata cotton into four pieces lengthwise to yield four 3½-inch- (9-cm-) wide strips. Cut four 5½-inch (14-cm) strips from the length of the blue solid.

Sew together the yukata cotton and blue solid with a ¼-inch (6-mm) seam allowance to yield 8½-inch- (21.5-cm-) wide strips. Keeping the long strips flat, press both seam allowances toward the yukata cotton. Then fold the facing strips in half lengthwise and press to reveal a scant ⅜-inch (1-cm) border of the blue solid on the yukata cotton side. As a finishing detail, stitch-in-the-ditch the seam between the yukata cotton and blue solid with thread that matches the blue solid. Trim the facing strips to 3¼ inches (8 cm) wide.

Position the facing strips, right side down, on the quilt front. Trim one end of each strip flush with the edge of the quilt sandwich and the other end 2 inches (5 cm) shy of the second edge. At each corner, place the short end of a facing strip on the top side to create a pinwheel-style look.

Stitch on the strips with a ¼-inch (6-mm) seam allowance and turn to the back for a 3-inch- (7.5-cm-) wide finished facing. Use thread matching the solid border for the invisible stitching.

Final Details

Name your quilt and add a label.

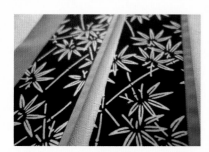

MAKE THE FACING STRIPS FOR HIDDEN WONDERS WITH A BORDER. ON THE LEFT IS AN UNTRIMMED FACING STRIP. ON THE RIGHT IS A TRIMMED FACING STRIP.

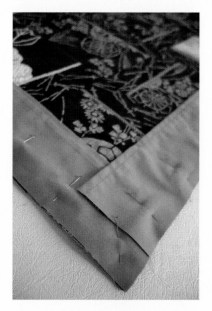

POSITIONED ON THE FRONT OF THE QUILT, THE WRONG SIDES OF THE FACING STRIPS ARE UP.

PINE NEEDLES

Lyrical grid spin-off

FINISHED QUILT
MEASURES
24 × 36 INCHES
(61 × 91 CM)

Pairs of pine needles are an auspicious motif in Japan, found on ceramics, metalwork, and textiles. The pine needle brackets joined together at the top suggest the fidelity of a marriage union, while their unchanging green represents prosperity.

The initial idea for Hidden Wonders included some blocks made with muted blue inset stripes. Standing back from the design wall, the blue stripes had little contrast compared to the red and yellow, so they were jettisoned from the composition. The rejected blocks were trimmed down to 6½ inches (16.5 cm) square to yield 6-inch (15-cm) finished blocks. Extra blocks with yellow inset stripes were also trimmed down and added to the small quilt layout. Remember, you can incorporate unused blocks from one quilt project into another to try out related concepts and color combos.

Sakura Spring

Wonky Stripes

The Japanese flock to see cherry blossoms, known as sakura, in early spring. They adore the clouds of delicate pink overhead and see the season as a new beginning—a time for optimism and hope.

Sakura Spring makes a joyous statement with just three patterned yukata cottons and five solids. The key to its vitality lies with the maverick white lines that cross the solids. The majority of blocks, made with the modish flowers on white, uses the half-patterned configuration, so there is plenty of width of color for three boisterous lines to cross. Two other solids—tangerine and persimmon—are intersected by four and two lively lines, respectively. Imagine this design with an alternate set of patterned fabrics, solids, and inset stripes. Everything shifts. That is the glory of improv. You don't want to follow where anyone has gone before. Instead, take an idea and run in a new direction.

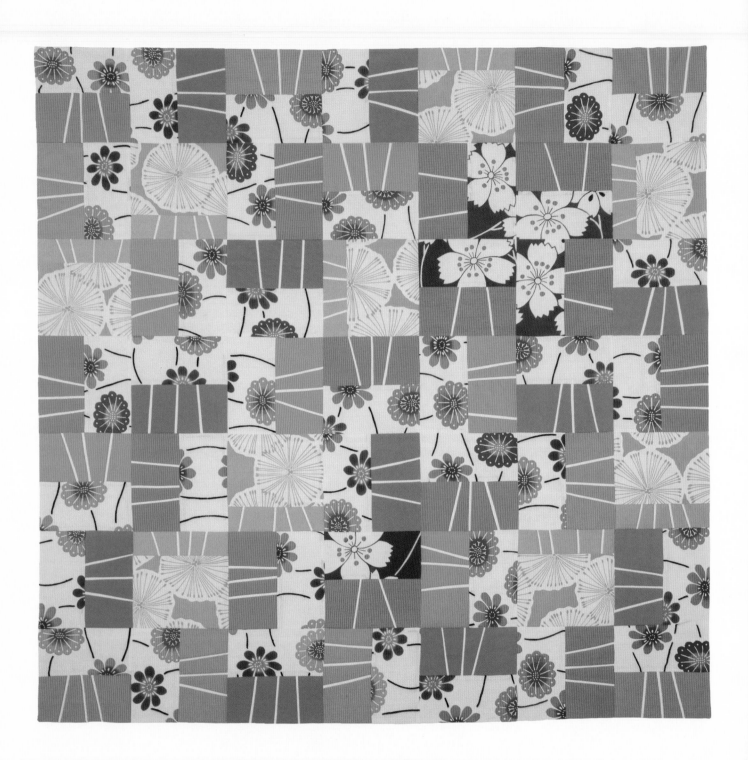

Sakura Spring

**FINISHED QUILT MEASURES
56 × 56 INCHES (142 × 142 CM)**

- Disorderly white lines enliven the composition
- One patterned fabric partners with three solids
- Sakura blossoms dance as the Unexpected Visitor

MATERIALS

Patterned Fabrics

Three contemporary fabrics (44–45 inches [112–114 cm] wide): minimum ¼ yard (23 cm) for the sakura blossoms on gray, minimum ½ yard (46 cm) for the large flowers on tangerine, and minimum 1½ yards (1.5 m) for the mod flowers on white OR three yukata cottons (14 inches [35.5 cm] wide): minimum 1 yard (1 m) for the sakura blossoms on gray, minimum 2 yards (2 m) for the large flowers on tangerine, and minimum 5 yards (5 m) for the mod flowers on white.

Solid Fabrics

Six solids (44–45 inches [112–114 cm] wide): minimum ¼ yard (23 cm) for the white, tangerine, and persimmon, minimum ½ yard (46 cm) for the dark orange and violet, and minimum ¾ yard (69 cm) for the hot pink.

MAKE THE QUILT TOP

Refer to the Make Your Quilt Top section at the back of the book for detailed instructions on making your quilt top.

Assemble your fabrics. For this quilt, the sakura blossom pattern on gray is the Unexpected Visitor.

Sakura Spring is made with forty-nine 8-inch (20-cm) blocks with five color combinations:

- Color A (mod flowers/hot pink): 13 blocks
- Color B (mod flowers/dark orange): 11 blocks
- Color C (mod flowers/violet): 11 blocks
- Color D (large flowers/tangerine): 9 blocks
- Color E (sakura on gray/persimmon): 5 blocks

Make the Rough Blocks

Sakura has 40 blocks with 1/2 patterns and 9 blocks with 3/4 patterns. There are no blocks with 1/4 patterns, as the paired solid with longer inset stripes looked out of balance in the composition. Keep this in mind when you rough cut your patterned fabrics and solids.

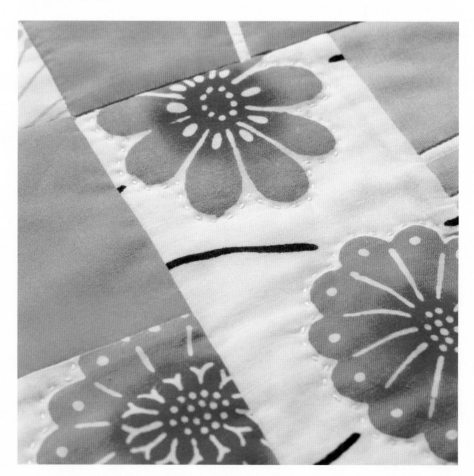

To allow for the seam allowances of the inset stripes, rough cut the solids bigger than standard: 6 × 12 inches (15 × 30.5 cm) for 1/2 solids and 4 × 12 inches (10 × 30.5 cm) for 1/4 solids. Slice across the width of each solid with randomly angled cuts, depending on your design. Keep the pieces of each cut-up solid together as a stacked set.

Across the width of the white, cut a 9-inch (23-cm) piece. Then precision cut ¾ × 9-inch (2 × 23-cm) strips for inset stripes.

Sew the inset stripes into the solids with ¼-inch (6-mm) seam allowances. To ensure the inset stripes stay an equal width along their lengths, keep them on top of the fabrics as you sew. Press the seam allowances to each side.

Trim across one side of the solids with inset stripes to prepare for sewing together as a rough block. Pair the patterned fabrics and the solids with inset stripes. Sew the rough blocks together, taking care to press the seams toward the patterned fabric.

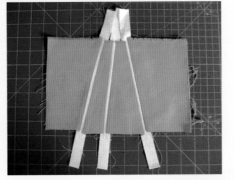
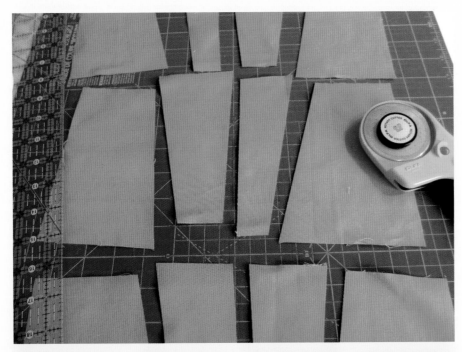

SLICE THE SOLIDS OF SAKURA SPRING RANDOMLY, AND SEW WHITE INSET STRIPES BETWEEN THE PIECES.

Trim Out the Rough Blocks

Trim the blocks with the Cutting Dance (page 149).

Develop the Design

Place the trimmed blocks on your design wall to develop the composition of your quilt top. Try different configurations, and switch out extra blocks for more variations.

Assemble Your Quilt Top

When you are happy with your design, sew all the blocks and rows together.

- -

FINISH YOUR QUILT

Refer to the Finishing Steps section at the back of the book for detailed instructions on completing your quilt.

Make Your Quilt Back

Make your quilt back whole cloth or pieced. Use what you have on hand or seek fabrics to complement or contrast your quilt top design, keeping in mind the fabrics you have available or planned for the facing. The final size should be 64 × 64 inches (163 × 163 cm). Press all seams open.

The back of Sakura Spring is made with an upcycled vintage yukata. Once the yukata was taken apart, I pieced it together with high-contrast inset stripes to mimic the quilt top. These stripes, made with 1-inch (2.5-cm) strips of dark burgundy cotton, are ½ inch (1.5 cm) wide. I pressed out the seams of the inset stripes on the back, and pressed open all other seams (see page 164 for photo).

Make and Sew the Quilt Sandwich

Pin baste the quilt sandwich. Stitch-in-the-ditch around all the blocks to secure the quilt sandwich. Stitch-in-the-ditch the inset stripes on the front of Sakura Spring with matching thread for an optional finishing detail. Tailor baste around the perimeter.

Design Your Hand-Stitching Pattern

With the inset stripes of Sakura Spring dominating the design focus, the hand stitching is a secondary detail. The freestyle hand-stitching design was not marked; instead, hand stitching, white thread on white, followed the fabric patterns.

Hand Stitch Your Quilt

Hand stitch, following the fabric patterns with matching thread.

Block and Trim Your Quilt

Block your quilt (see page 179), if you like. Trim your quilt and staystitch the perimeter of the quilt.

Make and Add the End Cap Facing

Refer to End Cap Facings (page 183) for detailed instructions on making and sewing on a facing.

The double-thick facing for Sakura Spring is wedge-shaped. To ensure there were no seams along its length, the facing used 1¾ yards (1.6 m) of contemporary fabric and 1¾ yards (1.6 m) of backing fabric.

Make a full-size facing pattern out of freezer paper: 54 inches long (137 cm), and 6½ inches (16.5 cm) wide on one end and 5 inches (13 cm) wide on the other. To make the four sides of the facing, you will need four facing strips made of the two fabrics. Iron the facing pattern twice to the front and twice to the back of each fabric, and cut out to yield four pieces of each.

Stitch together the front and backing fabric along the angled side. With the right sides of the fabric on your ironing board, press the seam toward the top facing fabric. Flip the facing strip on your ironing board and press the final edge with just a bit of the top facing fabric wrapping to the back.

Position the wedge-shaped facing strips, right side down, on the quilt front. On two opposing corners, pin the wide end of two facings flush with the edge of the quilt. On the other two corners, pin the narrow end of the two remaining facings flush with the edge of the quilt. Place the other end of all facing strips on top of the next strip in a pinwheel fashion.

Stitch on the strips with a ¼-inch (6-mm) seam allowance and turn to the back for a wedge-shaped facing with wide and narrow corners. Using thread matching the facing fabric for invisible stitching.

Final Details

Name your quilt and add a label.

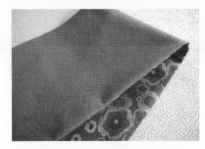

MAKE THE WEDGE-SHAPED FACING STRIPS FOR SAKURA SPRING WITH TWO FABRICS.

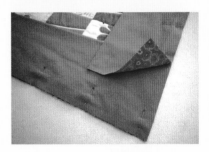

POSITION FACING STRIPS ON THE FRONT OF THE QUILT, WRONG SIDE UP.

(TOP LEFT) PRESS THE FREEZER PAPER PATTERN ONTO THE FACING FABRICS, THEN TRIM AROUND THE PATTERN USING A GRID RULER AND ROTARY CUTTER.

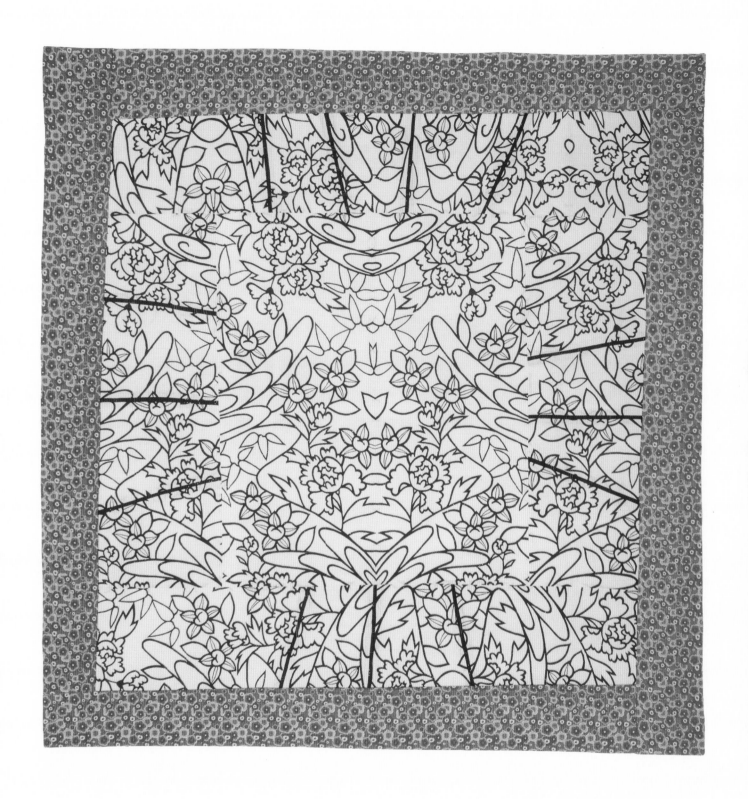

Japanese Textile Motifs

Traditional Japanese motifs, developed in the creative arts, are intrinsic to Japanese life. Nowadays you can find fabric-like patterns on everything from deluxe food packaging to currency to cell phone cases.

The very first cultural inspirations were imported from China and Korea during the T'ang dynasty (618–907). The foundation of foreign influences was eclipsed within 400 years as Japanese artisans reinterpreted and transformed the original art forms into their own.

For centuries, many patterns were restricted to certain classes. By the end of the 1800s, Japanese society became freer and new methods of production manifested a great burst of creativity. Wealthy citizens of Edo (now Tokyo) could wear once-imperial motifs such as chrysanthemums and butterflies.

Here are broad classes of traditional motifs, with a few examples:

Nature: flowing water, moon with grasses
Plant: bamboo, cherry blossoms
Animal: cranes, dragonflies
Geometric: tortoiseshell, zigzags
Domestic: ox cart wheels, bobbins
Complex: swallows and pine trees, flowers and dragonflies

Japanese textile artisans and fabric manufacturers continue to innovate. Today motifs span replications of sumptuous kimono silks to understated taupe graphics to kitschy Hello Kitty patterns.

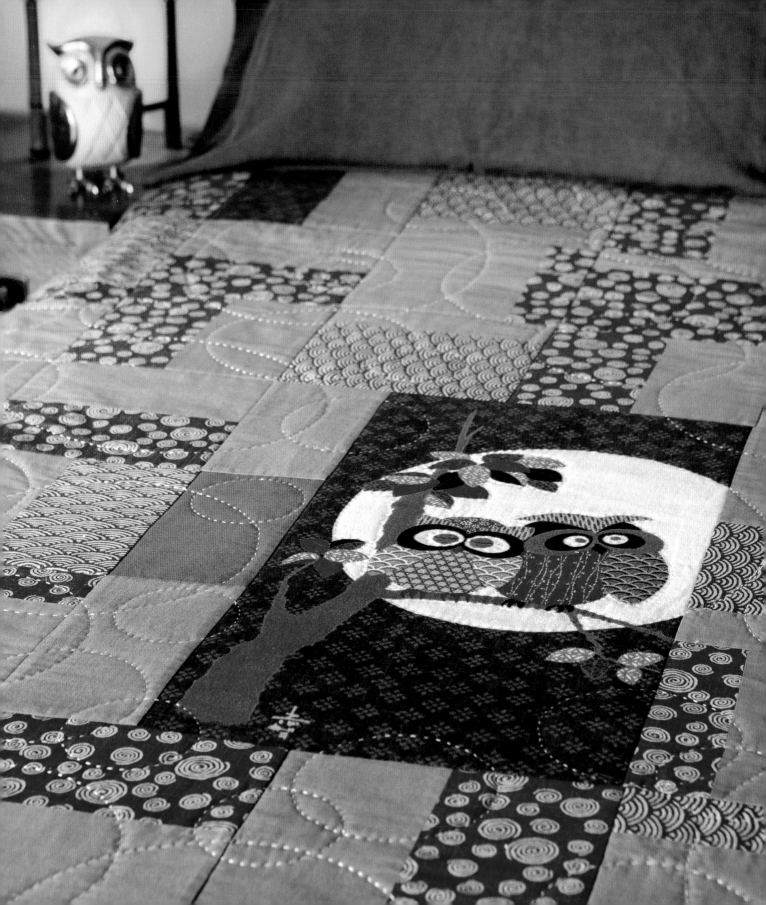

Lucky Owls

Noren Panel

The Japanese name for owl, written in a different set of characters, means luck. Cute owl key chains, stickers on mobile phones, and more are carried everywhere by Japanese citizens who believe in this charmed symbol.

Lucky Owls's graphic panel creates a focal point for the quilt top. Adding to the interest are a few blue-and-blue vertical blocks. For the background, two Japanese barn-red prints and a coffee-colored solid merge as one. If you look up close, the calico-like wave and swirl patterns are bright cream, so it would be easy to choose cream for the main solid. Yet once you audition a block or two with cream on your design wall, you immediately see how the light color pops too much. It's important to keep assessing your color choices as you put your quilt blocks together. Don't be afraid to change directions if you don't like what you see. And be sure to work in good light!

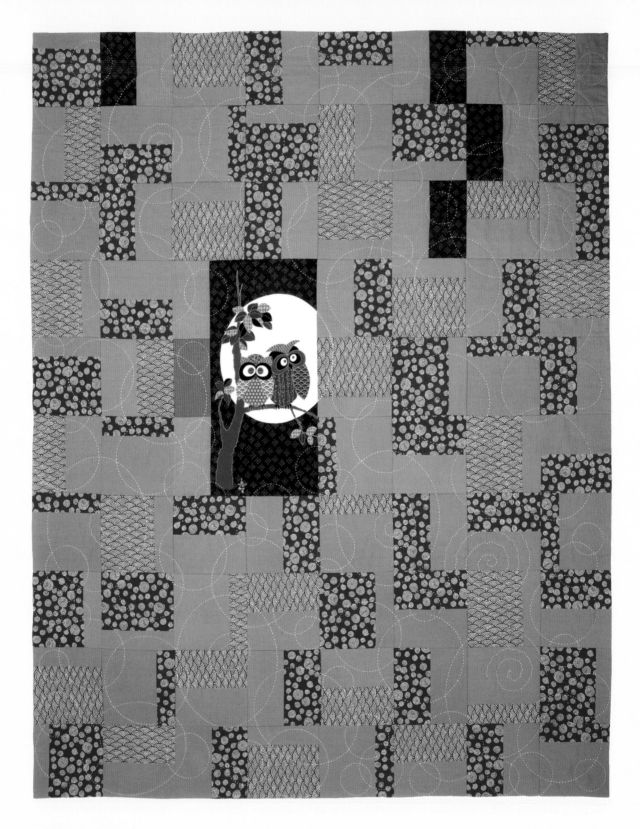

Lucky Owls

FINISHED QUILT MEASURES
64 × 80 INCHES
(162.5 × 200 CM)

- - - - - - - - - - - -

- **A large noren panel breaks the standard block formation**
- **The Unexpected Visitor, the scarlet bar, brightens the composition**
- **The circular stitching mimics the full moon shape**

- - - - - - - - - - - -

MATERIALS

Patterned Fabrics
Two contemporary fabrics (44–45 inches [112–114 cm] wide) and one panel: minimum 1½ yards (1.5m) for the wave pattern, minimum 2 yards (2 m) for the swirl pattern, and one 19 × 44-inch (48 × 112-cm) printed noren panel.

Solid Fabrics
Three solids (44–45 inches [112–114 cm] wide): minimum 5 × 9-inch (13 × 23-cm) scrap of scarlet, minimum ¼ yard (23 cm) for slate blue, and minimum 3 yards (3 m) for the coffee.

MAKE THE QUILT TOP

Refer to the Make Your Quilt Top section at the back of the book for detailed instructions on making your quilt top.

Assemble your fabrics. Look for equal color values with the patterns and solids so the noren panel becomes the focus. For this quilt, the scarlet solid is the Unexpected Visitor.

Lucky Owls is made with eighty 8-inch (20-cm) blocks with four color combinations:

- Color A (swirls on rust/coffee): 44 blocks
- Color B (waves on rust/coffee): 26 blocks
- Color C (slate blue/extra noren panel fabric): 4 blocks
- Color D (noren panel/scarlet red/slate blue): equal to 6 blocks

Precision Cut the Noren Panel Block Elements
Precision cut the noren panel to 12¼ × 24½ inches (31 × 62 cm). For the half blocks beside the noren panel, precision cut three 4½ × 8½-inch (11.5 × 21.5-cm) pieces—two slate blue and one scarlet.

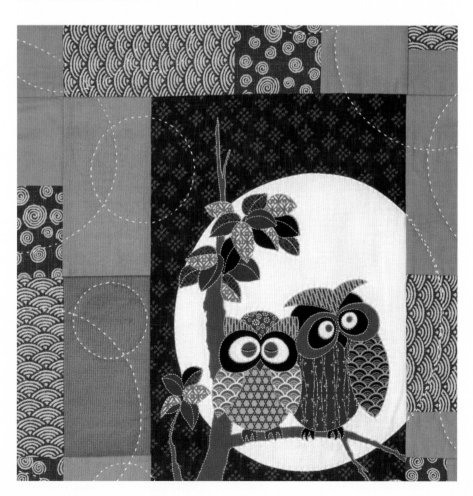

Make the Rough Blocks

Lucky Owls has 70 patterned blocks: 14 blocks with 1/4 patterns, 32 blocks with 1/2 patterns, and 24 blocks with 3/4 patterns. More than 75 percent of the blocks have the larger amount of patterns. Keep this ratio in mind when you rough cut your patterned fabrics and solids.

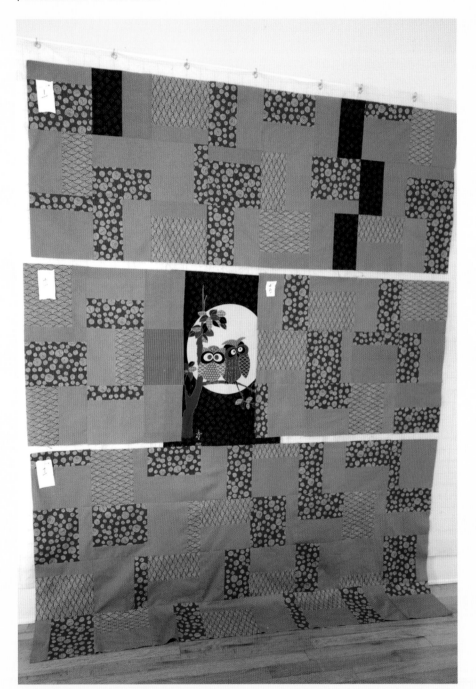

GETTING READY TO ASSEMBLE THE QUILT TOP FOR LUCKY OWLS.

LUCKY OWLS QUILT ASSEMBLY.

(LEFT) ASSEMBLE THE QUILT TOP OF LUCKY OWLS IN THREE BIG HORIZONTAL PIECES.

Rough cut the remaining noren fabric and the slate blue each into four 5 × 9-inch (13 × 23-cm) pieces to be used in the double-solid blocks.

For the 70 patterned blocks and four double-solid blocks, sew the rough blocks together and press the seams open.

Trim Out the Rough Blocks

Trim the blocks with the Cutting Dance (page 149).

Develop the Design

Place the trimmed blocks on your design wall to develop the composition of your quilt top. Try different configurations, and switch out extra blocks for more variations. Place the half-blocks of slate blue and scarlet alongside the noren panel on your design wall.

Assemble Your Quilt Top

When you are happy with your design, sew all the blocks and rows together, except the three rows with the noren panel.

Sew the blocks to the left of the noren panel into three rows, adding the half-blocks to the end of each row. Then sew the rows together with horizontal seams.

Sew the blocks to the right of the noren panel into three rows. Then sew the rows together with horizontal seams.

Sew the noren panel to the three rows on the left. Then sew the noren panel plus left rows to the three rows on the right.

Continue assembling your quilt top.

- -

FINISH YOUR QUILT

Refer to the Finishing Steps section at the back of the book for detailed instructions on completing your quilt.

Make Your Quilt Back

Make your quilt back whole cloth or pieced. Use what you have on hand or seek fabrics to complement or contrast your quilt top design, keeping in mind the fabrics you have available or planned for the facing. The final size should be 72 × 88 inches (183 × 223.5 cm). Press all seams open.

The back of Lucky Owls is made with a 2½-yard (2.5-m) length of coordinated owl fabric, flanked by four 9½ × 30-inch (24 × 76-cm) strips of coffee and five 9½ × 30-inch (24 × 76-cm) strips of bright cream, sewn together as alternating stripes.

Make and Sew the Quilt Sandwich

Pin baste the quilt sandwich. Stitch-in-the-ditch around the blocks to secure the quilt sandwich. Tailor baste around the perimeter.

Design and Mark Your Hand-Stitching Pattern

Look at your quilt front and back fabrics to inspire your stitching pattern. The hand-stitching on Lucky Owls mirrors the round circle of the full moon graphic. Use a white chalk pencil to trace round shapes (like vintage diner china—oval and round plates, a

small bowl, and a coffee cup). Hand draw swirl motifs, from the front patterned fabric, directly onto the quilt top.

Hand Stitch Your Quilt

Hand stitch, following the white lines. Echo quilt around the owls to secure the fabric in the noren panel.

Block and Trim Your Quilt

Block your quilt (see page 179), if you like. Trim your quilt and stay-stitch the perimeter of the quilt.

Make and Add the End Cap Facing

Refer to End Cap Facings (page 183) for detailed instructions on making and sewing on a facing.

The double-thick facing for Lucky Owls is made with scraps from the project. Connect eight 8-inch- (20-cm-) wide pieces of the blue-gray, in lengths varying from 20 to 24 inches (51–61 cm) long, with 1 × 8-inch (2.5 × 20-cm) leftover pieces of the noren fabric to make a strip approximately 4 yards (4 m) long.

For the top and bottom of the facing, sew two 38 × 8-inch (96.5 × 20-cm) pieces of the owl backing fabric to lengths of the blue-gray with connectors to yield 64-inch (163-cm) strips. Fold the pieced strips in half lengthwise and trim to 3¾ inches (9.5 cm) wide. Position the facing strips on the front side of the quilt, from edge to edge, across the top and bottom.

For the left side, sew together 9½ × 8-inch (24 × 20-cm) pieces of brown and bright cream on the short sides as alternating stripes to make a 78-inch (198-cm) facing strip. Fold in half lengthwise, then trim the strip to 3¾ inches (9.5 cm) wide. Position on the front of the quilt with the top edge of the strip at the top of the quilt. The bottom of the facing strip sits on top of the bottom facing strip, shy of the edge of the quilt.

For the right side, fold the remaining strip of blue-gray fabric with connectors in half lengthwise and trim to 78 inches (198 cm) long and 3¾ inches (9.5 cm) wide. Position on the front of the quilt with the top edge of the strip at the top of the quilt. The bottom of the facing strip sits on top of the bottom facing strip, shy of the edge of the quilt.

Make sure all the facing strips on the front of the quilt are right side down. Stitch on the strips with a ¼-inch (6-mm) seam allowance and turn to the back for a 3½-inch- (9-cm-) wide finished facing. Use thread matching each facing fabric for the invisible stitching.

Final Details

Name your quilt and add a label.

(TOP) USE WHAT YOU HAVE ON HAND TO TRACE THE CIRCULAR AND OVAL STITCH PATTERN SHAPES FOR LUCKY OWLS—IN THIS CASE, VINTAGE DINER CHINA.

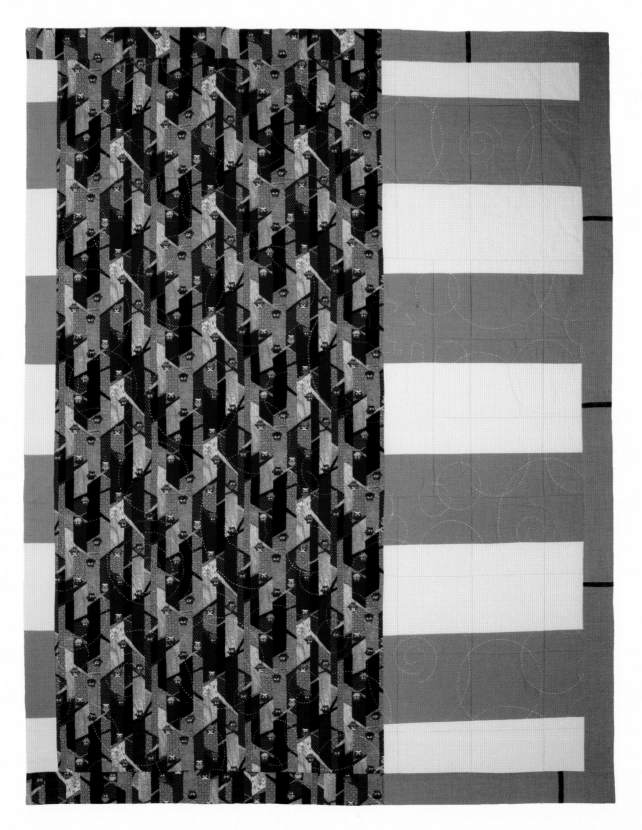

Festival

Incorporating Chevrons

In contrast to the normally subdued palette of daily life in Japan, festivals explode with color. Elaborate floats, garish costumes, food stalls, carnival games, dancing, and fireworks celebrate a rotating schedule of summer holidays in every region.

All the design elements of Festival contribute to its dynamic style. Chevrons zigzag, colors shout, crazy circles take over whole blocks, and yarn ties provide a third dimension. Except for the chevrons, I bought the cottons for this quilt at designer stores. Mostly from Europe, the vivacious patterns could easily be mistaken for modern Japanese motifs. Don't shy away from atypical fabrics for your quilts. The outrageous calligraphic cotton used for the backing includes 3 percent spandex. The little bit of stretch didn't affect the sewability of the quilt sandwich, and its high-powered pattern extends the quilt's visual punch to the second side.

Festival

FINISHED QUILT MEASURES
56 × 64 INCHES (142 × 163 CM)

- **Chevrons span most blocks**
- **A chunk of bright pink pops as the Unexpected Visitor**
- **Fat orange yarn ties the quilt together at block intersections**

MATERIALS

Patterned Fabrics
Six contemporary fabrics (44–45 inches [112–114 cm] wide): minimum ¼ yard (23 cm) for one graphic pattern, and minimum ½ yard (46 cm) each for five graphic patterns, including one oversize pattern.

Chevron Fabrics
Three 2-inch (5-cm) chevron fabrics (44–45 inches [112–114 cm] wide): minimum ¼ yard (23 cm) of the red, minimum ½ yard (46 cm) of the black and orange.

Solid Fabrics
Six solids (44–45 inches [112–114 cm] wide): minimum 5 × 9-inch (13 × 23-cm) scrap of pink, minimum ½ yard (46 cm) each for the lilac, red, yellow, light orange, and orange.

MAKE THE QUILT TOP

Refer to the Make Your Quilt Top section at the back of the book for detailed instructions on making the quilt top.

Assemble your fabrics. Look for high contrast in your collection for this quilt, including one oversize pattern. For this quilt, the bright pink is the Unexpected Visitor.

Festival is made with fifty-six 8-inch (20-cm) blocks with seven color combinations:

- Color A (stripes/black chevron on white/lilac): 12 blocks
- Color B (big flowers/red chevron on white/red): 11 blocks
- Color C (crazy circles/no chevron/no solid): 10 blocks
- Color D (black dots on white/white chevron on black/yellow): 9 blocks
- Color E (white blobs on black/white chevron on orange/light orange): 7 blocks
- Color F (white dots on black/orange chevron on white/orange): 6 blocks
- Color G (white blobs on black/white chevron on red/pink): 1 block

Precision Cut Ten Blocks
Precision cut the fabric with the oversize pattern into 8½ × 8½-inch (21.5 × 21.5-cm) squares.

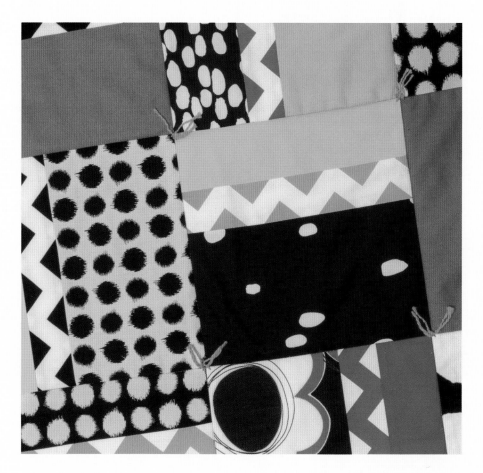

Prep the Chevrons

For the chevrons, cut 9-inch (23-cm) strips across the grain. Cut out individual chevrons by cutting across the 9-inch (23-cm) strips, lining up your grid ruler at the points of the chevron. For colored chevrons on white, cut across the top and bottom of the colored zigzags. For white chevrons on a color, cut across the top and bottom of the white zigzags.

Make the Rough Blocks with the Chevrons

Festival has 46 chevron blocks with zero blocks with 1/4 patterns, 16 blocks with 1/2 patterns, and 30 blocks with 3/4 patterns. All the chevron blocks have the larger amount of patterns. Keep this ratio in mind when you rough cut your patterned fabrics and solids for the chevron blocks.

Rough cut the patterned and paired solids. To account for the chevron insert, rough cut the patterns 1-inch (2.5-cm) narrower than standard for Hachi Quilt blocks. For blocks with 1/2 patterns, rough cut patterned fabrics 4 inches (10-cm) wide. For blocks with 3/4 patterns, rough cut patterned fabrics 6 inches (15 cm) wide. Sew the rough blocks together with the chevron seamed between the pattern and solid. Press the seams open.

Trim Out the Rough Blocks

Trim the blocks with the Cutting Dance (page 149).

Consider the chevron as part of the patterned side of the block for lining up the seams under the grid ruler.

Develop the Design

Place the trimmed blocks on your design wall to develop the composition of your quilt top. Try different configurations, and switch out extra blocks for more variations.

Assemble Your Quilt Top

When you are happy with your design, sew all the blocks and rows together.

FINISH YOUR QUILT

Refer to the Finishing Steps section at the back of the book for detailed instructions on completing your quilt.

Make Your Quilt Back

Make your quilt back whole cloth or pieced. Use what you have on hand or seek fabrics to complement or contrast your quilt top design, keeping in mind the fabrics you have available or planned for the facing. The final size should be 64 × 72 inches (163 × 183 cm). Press all seams open.

The back of Festival is made with 2 yards (2 m) of 60-inch- (152-cm) wide designer cotton with a calligraphic pattern. I added two 4 × 72-inch (10 × 183-cm) extension strips to each side of the designer fabric to make the required back size.

ARE CHEVRONS A JAPANESE MOTIF?

The Japanese are stellar at refining objects down to their simplest graphic shape. The zigzag shapes of chevrons are recognized as mountains forms in Japan—a well-known pattern called *yamagata*.

Make and Sew the Quilt Sandwich

Pin baste the quilt sandwich. Stitch-in-the-ditch around the blocks to secure the quilt sandwich. Tailor baste around the perimeter.

Tie Your Quilt

Festival is double-tied at every block intersection with bulky cotton yarn for a three-dimensional finishing touch. For each tie, punch four holes through the quilt sandwich from the front using a heavy-duty glover's leather-working needle and light hammer. (Be sure to work on a piece of scrap hardwood and not right on top of your worktable.)

PUNCH HOLES INTO FESTIVAL AND DOUBLE-TIE THE YARN AT EACH BLOCK INTERSECTION.

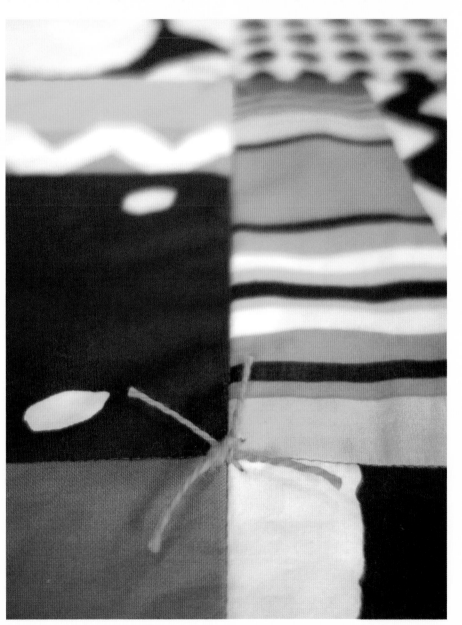

Load contrasting-colored yarn onto a big-eye needle and push straight through the quilt sandwich from the top until a 6-inch (15-cm) tail of yarn is left on the front side. Flip to the back side, then push the needle back to the front through the kitty-corner hole.

Push the needle from the front through the third hole, and pull through to the back until a 6-inch (15-cm) loop of yarn is left on top. Flip to the back side, then push the needle back to the front via the fourth hole. Pull the yarn through and trim the yarn 6 inches (15 cm) from the quilt top.

Cut the yarn loops and tie into two knots using yarn tails from opposing holes. Pull the square knots—left over right, right over left—tight and trim the tails to 1¼ inches (3 cm). The yarn tie on the back side makes a colorful little X.

Block and Trim Your Quilt

Block your quilt (see page 179), if you like. Trim your quilt and staystitch the perimeter of the quilt.

Make and Add the End Cap Facing

Refer to End Cap Facings (page 183) for detailed instructions on making and sewing on a facing.

The double-thick facing for Festival is made with a 9 × 11-inch (23 × 28-cm) scrap of black chevron, ½ yard (46 cm) of orange chevron, and 1½ yards (1.5 m) of red chevron. Cut the chevron yardage into 9-inch (23-cm) strips across the grain. Cut the strips to random lengths and piece back together to make the facing strips—two 56-inch (142-cm) strips for the top and bottom, and two 60-inch (152-cm) strips for the sides. Press the strips in half lengthwise and trim to 3¾ inches (9.5 cm) wide.

Position the facing strips, right side down, on the quilt top. Pin the top and bottom strips across the width of the quilt sandwich. Pin the side strips on top of the top and bottom strips.

Stitch on the strips with a ¼-inch (6-mm) seam allowance and turn to the back for a 3½-inch (9-cm) finished facing. Use white thread for the invisible stitching.

To create the white squares at the seams, include an extra ¼ inch (6 mm) of the next zigzag in the cut, past the needed chevron peak.

Final Details

Name your quilt and add a label.

IS TYING A QUILT A GOOD IDEA?

You may have been taught that tying is not the best way to secure a quilt. That's because the batting between the ties can shift and bunch. With Festival, the stitching-in-the-ditch holds everything together. The orange yarn ties are a cosmetic detail that add dimension, a hit of color, and a graphic X on the back side.

(LEFT) PRECISION CUTTING THE CHEVRON FABRIC YIELDS WHITE SQUARES IN THE FACING DESIGN OF FESTIVAL.

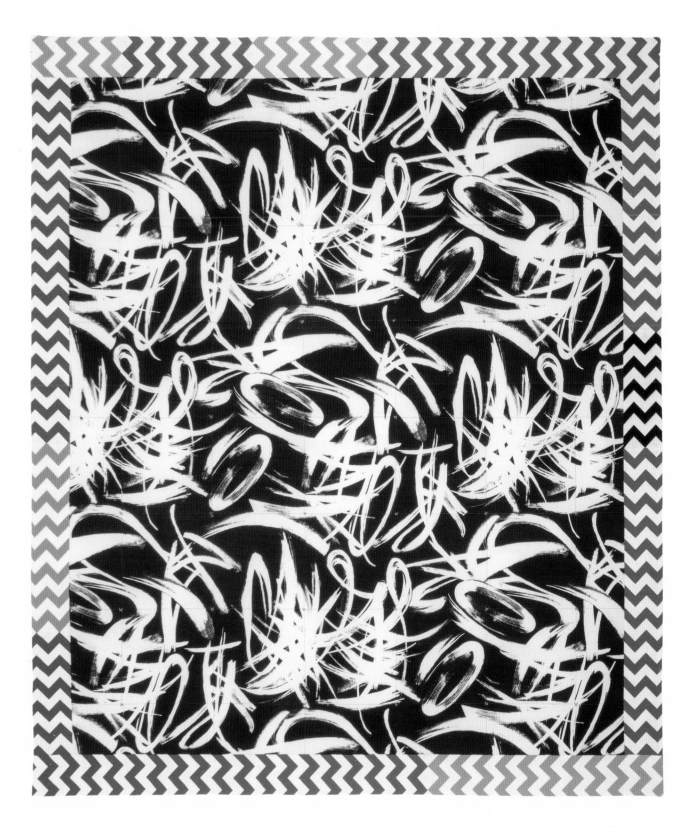

Lotus

Vertical Blocks

The lotus is revered in Japan for its ability to rise above murky waters and become a divine flower with a delicate fragrance. Lotus viewers often visit lakes and ponds at dawn to watch the blossoms crack open in the early light of day.

Floral patterns abound in Japanese textiles and today's quilting cottons. Lotus, made with Japanese-inspired fabrics plus sherbet-colored solids, tells the story of a sunny summer garden. The collection of printed fabrics came from friends' stashes. It's always fun to see how gifted treasures can open you up to novel color combinations. The assemblage included a tiny piece of Kaffe Fassett's Lake Blossoms (paired with turquoise) and a scrap of Amy Butler's Floating Buds (paired with hot pink). Not an inch of either was wasted, as they inspired the Lotus theme.

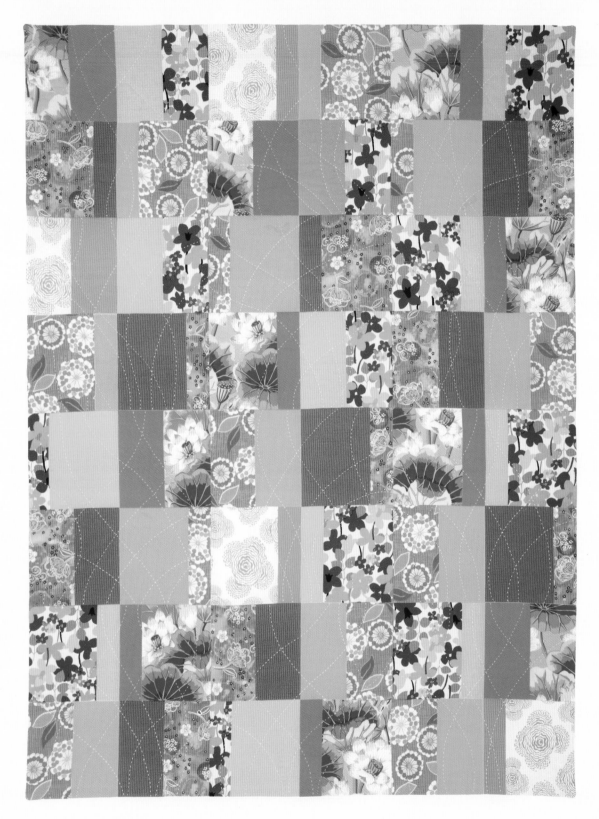

Lotus

FINISHED QUILT MEASURES
48 × 64 INCHES (122 × 163 CM)

- - - - - - - - - - - - - - - - -

- The solid colors align on three spines
- The dark mauve bar quietly arrives as the Unexpected Visitor
- The hand-stitching pattern resembles undergrowth in a tangled garden

- - - - - - - - - - - - - - - - -

MATERIALS

Patterned Fabrics

Five contemporary fabrics (44–45 inches [112–114 cm] wide): minimum ¼ yard (23 cm) of one floral pattern and minimum ½ yard (46 cm) each for four floral patterns.

Solid Fabrics

Six solids (44–45 inches [112–114 cm] wide): minimum 5 × 9-inch (13 × 23-cm) scrap of dark mauve, minimum ¼ yard (23 cm) for the hot pink, and minimum ½ yard (46 cm) each for the chartreuse, salmon, turquoise, and magenta.

MAKE THE QUILT TOP

Refer to the Make Your Quilt Top section at the back of the book for detailed instructions on making your quilt top.

Assemble your fabrics. Look for liveliness in your palette with contrast among the solids. For this quilt, the dark mauve is the Unexpected Visitor.

Lotus is made with forty-eight 8-inch (20-cm) blocks with six color combinations:

- Color A (Floral One/chartreuse): 12 blocks
- Color B (Floral Two/salmon): 11 blocks
- Color C (Floral Three/turquoise): 10 blocks
- Color D (Floral Four/magenta): 10 blocks
- Color E (Floral Five/hot pink): 4 blocks
- Color F (Floral Two/dark mauve): 1 block

Make the Rough Blocks

Lotus has 8 blocks with 1/4 solids, 20 blocks with 1/2 solids, and 20 blocks with 3/4 solids. Almost 85 percent of the blocks have the larger amount of pattern. Keep this ratio in mind when you rough cut your patterned fabrics and solids.

Sew the rough blocks together and press the seams open.

Trim Out the Rough Blocks

Trim the blocks with the Cutting Dance (page 149).

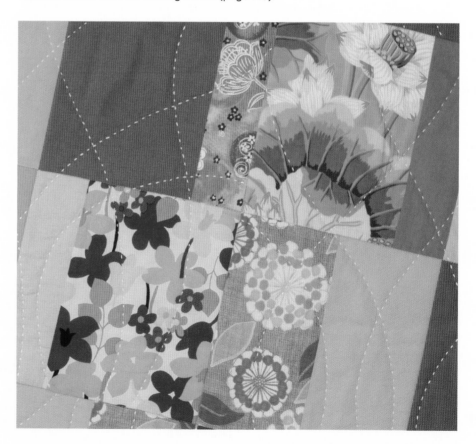

Develop the Design

Place the trimmed blocks on your design wall to develop the composition of your quilt top. Keep the blocks vertical and line up the color bars between Blocks 1 and 2, Blocks 3 and 4, and Blocks 5 and 6. Choose a different color for each corner of the four-way intersections. Also, vary the bar width so no bars of equal width stack on top of one another. Try different configurations, and switch out extra blocks for more variations.

Assemble Your Quilt Top

When you are happy with your design, sew all the blocks and rows together.

FINISH YOUR QUILT

Refer to the Finishing Steps section at the back of the book for detailed instructions on completing your quilt.

Make Your Quilt Back

Make your quilt back whole cloth or pieced. Use what you have on hand or seek fabrics to complement or contrast your quilt top design, keeping in mind the fabrics you have available or planned for the facing. The final size should be 56 × 72 inches (142 × 183 cm). Press all seams open.

 The back of Lotus is whole cloth, made with 2 yards (2 m) of organic 7-ounce cotton twill that is 90 inches (228.5 cm) wide.

Make and Sew the Quilt Sandwich

Pin baste the quilt sandwich. Stitch-in-the-ditch around the blocks to secure the quilt sandwich. Tailor baste around the perimeter.

Design and Mark Your Hand-Stitching Pattern

Look at your quilt front and back fabrics to inspire your stitching pattern. For Lotus, I drew upward-curving lines freehand on the quilt top with a blue water-soluble marking pen. I crossed the curved lines in the solid areas as much as possible to accent the tangled-garden stitch design.

Hand Stitch Your Quilt

Hand stitch, following the blue lines. I used white no. 5 perle cotton thread with a bigger-than-normal stitch length to create a modern look.

Block and Trim Your Quilt

Block your quilt (see page 179), if you like. Trim your quilt and staystitch the perimeter of the quilt.

Make and Add the End Cap Facing

Refer to End Cap Facings (page 183) for detailed instructions on making and sewing on a facing.

 The double-thick facing for Lotus is made with 1 yard (1 m) of the 90-inch- (228.5-cm-) wide organic cotton twill used for the back. Cut four 8-inch- (20-cm-)

AFTER APPLYING STEAM FROM AN IRON, PRESS A TAILOR'S CLAPPER ON THE EDGE OF THE FACING TO REDUCE THE BULKINESS OF THE HEAVY-WEIGHT COTTON TWILL.

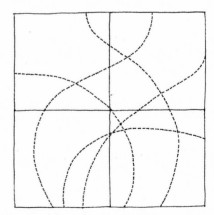

USE THREADS THAT MATCH THE FACING FABRICS FOR THE BLIND STITCHING.

EXAMPLE OF THE STITCHING PATTERN FOR FOUR BLOCKS OF LOTUS.

wide strips across the grain. Piece small scraps of 8-inch- (20-cm-) wide solid fabrics into two of the strips. Press the long facing strips in half lengthwise and trim to 3⅝ inches (9.5 cm).

Position the facing strips, right side down, on the quilt top. Trim the top and bottom strips to the exact width of the quilt sandwich. Trim the side strips 3 inches (7.5 cm) shorter than the quilt length. Place the side strips on top of the top and bottom strips.

Stitch on the strips with a ¼-inch (6-mm) seam allowance and turn to the back for a 3⅜-inch- (8.5-cm-) wide finished facing. Use thread matching each facing fabric for the invisible stitching.

Final Details
Name your quilt and add a label.

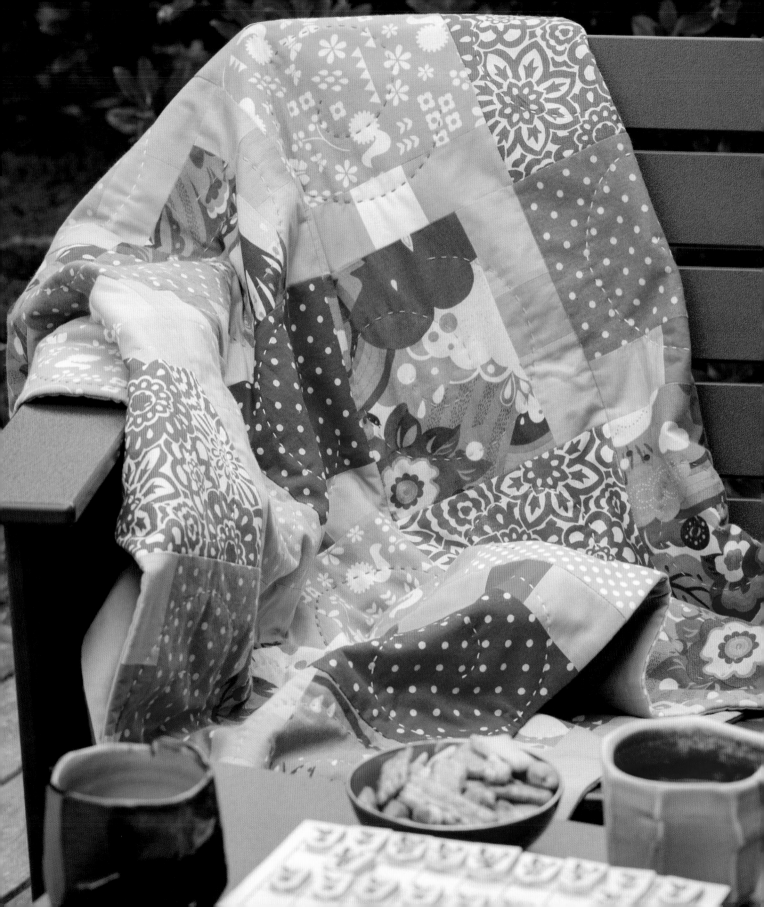

Harmony

Highlight Squares

Translated as wa, harmony is an important influence in Japanese culture that impacts social, business, and political behavior. Personal conduct in Japan is modulated to ensure harmony above all else in every interaction.

Similar to old-fashioned hopsacking, Japanese mills produce a cotton-linen fabric suitable for quilting. These fabrics are on the slightly heavier side, and tend to have a muted palette with an unbleached white base. A delightful pattern on cotton-linen—resplendent with rainbows, trees, birds, flowers, and snails—inspired this quilt project. In the end, the fantasy fabric became the backing, with a small amount used in the top. All the blocks conform to the 3/4-pattern configuration, with highlight squares of color centered in every solid. A spontaneous swirl of hand-stitching through each block completes the design.

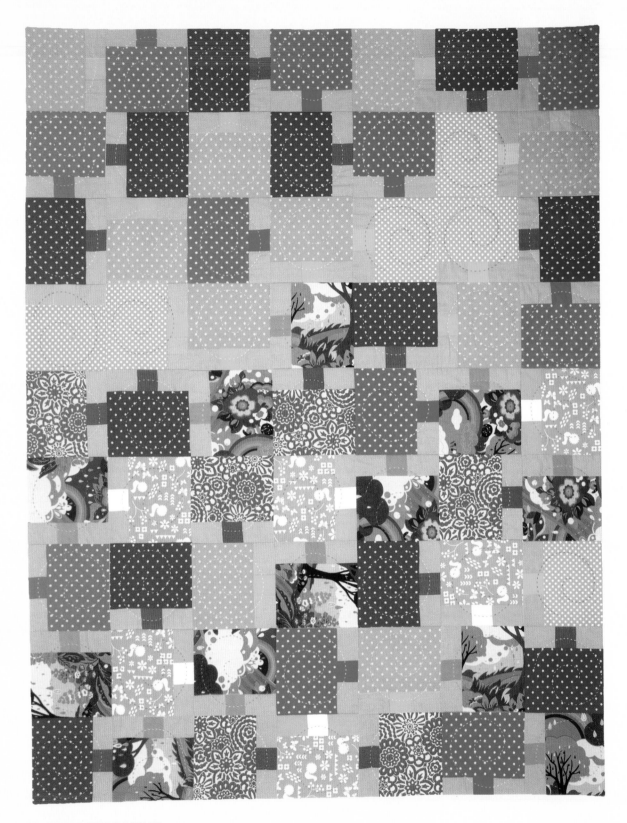

Harmony

FINISHED QUILT MEASURES
56 × 72 INCHES (142 × 183 CM)

- - - - - - - - - - - - - - -

- **A square of color sits in the center of every solid**
- **A family of orange blocks appears as the Unexpected Visitor**
- **The spiral stitch pattern across every block supports the harmony theme**

- - - - - - - - - - - - - - -

MATERIALS

Patterned Fabrics
Seven contemporary fabrics (44–45 inches [112–114 cm] wide): minimum ¼ yard (23 cm) for the orange dot, pink floral, and roosters on green; and minimum ½ yard (46 cm) for chartreuse dot, blue dot, red dot, and rainbow pattern.

Solid Fabrics
Two solids (44–45 inches [112–114 cm] wide): minimum ¼ yard (23 cm) for the soft avocado, and minimum 1½ yards (1.5 m) for the gray.

Highlight Squares
Seven solids (44–45 inches [112–114 cm] wide): minimum ¼ yard (23 cm) for turquoise, red, blue, chartreuse, pink, natural white, and orange.

MAKE THE QUILT TOP

Refer to the Make Your Quilt Top section at the back of the book for detailed instructions on making your quilt top.

Assemble your fabrics. Look for a lively but low-contrast palette with one dissonant color. Match your main patterns with bright solids for the highlight squares. For this quilt, the orange is the Unexpected Visitor.

Harmony is made with sixty-three 8-inch (20-cm) blocks with seven color combinations:

- Color A (rainbow pattern/turquoise square/gray): 12 blocks
- Color B (red dot/red square/gray): 12 blocks
- Color C (blue dot/blue square/gray): 11 blocks
- Color D (chartreuse dot/chartreuse square/gray): 10 blocks
- Color E (pink floral/pink square/gray): 6 blocks
- Color F (roosters on green/natural white square/soft avocado): 6 blocks
- Color G (orange dot/orange square/gray): 6 blocks

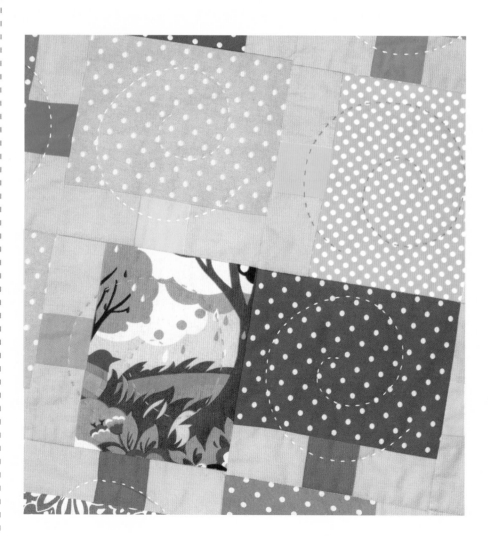

Think About Your Block Needs

Harmony has 39 blocks with dot patterns and 24 blocks with other patterns. About 60 percent of the blocks have the dot pattern and 40 percent have the other patterns. Keep this ratio in mind when you rough cut the patterned fabrics and prep the solids with the highlight squares.

Prep the Precision-Cut Highlight Squares with Solids

Cutting across the width of the highlight square fabrics, precision cut 2½-inch (6-cm) strips. Cutting across the width of your solid fabrics, cut 4-inch (10-cm) strips of gray and soft avocado.

Sew a strip of the appropriate solid to the top and bottom of the highlight strips, making a long sandwich strip. Press the seams open.

Cut 3-inch- (7.5-cm-) wide pieces off the sandwich strips for the rough blocks. Be sure the cuts across the sandwich strips are perpendicular to the highlight squares.

Make the Rough Blocks

Rough cut 7 × 9-inch (18 × 23-cm) pieces of all the patterned fabrics. Pair up the patterned fabrics with the appropriate solid/highlight square.

Sew the rough blocks together. For directional fabric such as the rainbow pattern, sew solid/highlight squares to both sides of these rough blocks. Press the seams open.

Trim Out the Rough Blocks

Trim the blocks with the Cutting Dance (page 149).

Position the pattern/solid seam under the 2¼-inch (6-cm) marking on the grid ruler. For the second set of cuts, position the highlight square between the 3¼-inch (8-cm) and 5¼-inch (13.5-cm) markings on the ruler. To aid in cutting, add tape to the ruler on top of these two measurement lines. (Don't place tape under the suction cups—they won't hold.)

Develop the Design

Place the trimmed blocks on your design wall to develop the composition of your quilt top. Try different configurations, and switch out extra blocks for more variations.

For the first iteration of Harmony on the design wall, there was an overall sprinkling of all the fabrics across the quilt. Ultimately I grouped the dot patterns on one end and patterned fabrics on the other, with a crossing over at the center. This created the most harmonious layout.

Assemble Your Quilt Top

When you are happy with your design, sew all the blocks and rows together.

MAKE A LONG SANDWICH STRIP WITH THE SOLID AND HIGHLIGHT SQUARE FABRICS. SLICE INTO 3-INCH- (7.5-CM-) WIDE PIECES.

PREP SOLIDS WITH HIGHLIGHT SQUARES FOR ALL THE COLOR COMBOS.

PAIR THE SOLIDS WITH HIGHLIGHT SQUARES WITH THE ROUGH-CUT PATTERNED FABRICS.

(LEFT) YOU CAN EASILY TRIM OUT THE BLOCKS FOR HARMONY BY ADDING TAPE GUIDES TO THE GRID RULER FOR THE SECOND SET OF CUTS.

FINISH YOUR QUILT

Refer to the Finishing Steps section at the back of the book for detailed instructions on completing your quilt.

Make Your Quilt Back

Make your quilt back whole cloth or pieced. Use what you have on hand or seek fabrics to complement or contrast your quilt top design, keeping in mind the fabrics you have available or planned for the facing. The final size should be 64 × 80 inches (163 × 200 cm). Press all seams open.

The back of Harmony is made with 4½ yards (4.5 m) of the rainbow-patterned cotton-linen. Cut the fabric in half to yield two 2¼-yard (2-m) lengths. Trim one length to 24 × 81 inches (61 × 206 cm) by cutting 10 inches (25 cm) off each side. Cut the second length down the middle to yield two 22 × 81-inch (56 × 206-cm) pieces. Sew the two 22-inch- (56-cm-) wide pieces, with the pattern upside down, to either side of the 24-inch- (61-cm-) wide piece, with the pattern upright.

Make and Sew the Quilt Sandwich

Pin baste the quilt sandwich. Stitch-in-the-ditch around the blocks to secure the quilt sandwich. Tailor baste around the perimeter.

Design and Mark Your Hand-Stitching Pattern

Look at your quilt front and back fabrics to inspire your stitching pattern. The hand-stitching on Harmony is a spiral, the sacred symbol of balance. The spirals, hand drawn on every block with a blue water-soluble marking pen, start in the middle of the patterned fabric and twirl through the highlight squares. Stitching with different-colored threads adds interest to the simple stitching pattern.

Hand Stitch Your Quilt

Hand stitch, following the blue lines. Change thread colors if it suits your design.

Block and Trim Your Quilt

Block your quilt (see page 179), if you like. Trim your quilt and staystitch the perimeter of the quilt.

Make and Add the End Cap Facing

Refer to End Cap Facings (page 183) for detailed instructions on making and sewing on a facing.

The double-thick facing for Harmony is made with 1½ yards (1.5 m) of the gray solid used on the front, plus scrap pieces of the highlight square fabrics. The finished facing width on the top and bottom is 3⅞ inches (9.8 cm) wide and on the sides is 3 inches (7.5 cm) wide.

For the top and bottom of the facing, cut the highlight square fabric to 4⅜ × 10 inches (11 × 25 cm) and seam to two 10 × 44-inch (25 × 112-cm) strips of gray. Fold the pieced strips in half lengthwise, trim to 4⅛ inches (10.5 cm) wide, and position, right side down, on the quilt top for sewing. Trim strips to the exact width of the quilt.

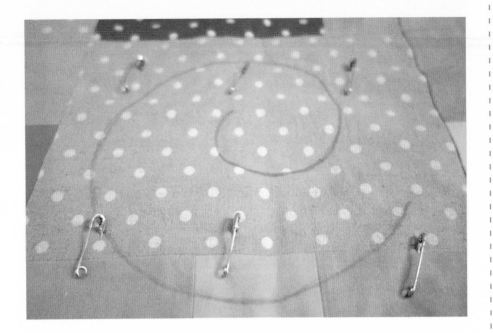

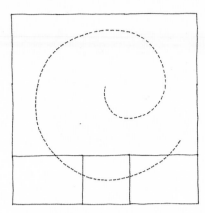

HAND DRAW THE STITCH PATTERN FOR HARMONY ON EACH BLOCK.

For the sides of the facing, cut the highlight square fabric to 3½ × 8 inches (9 × 20 cm) and seam to two 8 × 44-inch (20 × 112-cm) strips of gray. Fold the pieced strips in half lengthwise and trim to 3¼ inches (8 cm) wide. Trim the side pieces of the facing to 70 inches (178 cm), and position, right side down, on the quilt top for sewing.

Stitch on the facing strips with a ¼-inch (6-mm) seam allowance and turn to the back. Use thread matching each facing fabric for the invisible stitching.

Final Details
Name your quilt and add a label.

Gilded Garden

Border Treatment

Known as the "son of the sun," gold plays a role in both power and religion in Japan. Royal personages wear gold, while golden statues of Buddha glitter in temples across the land. In addition, fields of life-giving rice are called "golden waves."

When you ask for Japanese fabrics in most quilt shops, staff members will point to fancy cottons with reproductions of Japanese kimono silks overprinted in metallic gold. These luscious fabrics hold up well to the rigors of quilting—prewashing, sewing, pressing, and stitching. The same does not hold true for all gold threads. Make sure any gold thread you choose will not tarnish in the air or turn black from moisture. The hand-stitching thread used in Gilded Garden is a synthetic braid from a needlework shop. Good news: The faux-gold thread will remain sparkly over time. Bad news: It will melt if unprotected from high heat, so be sure to use a pressing cloth when ironing your finished quilt.

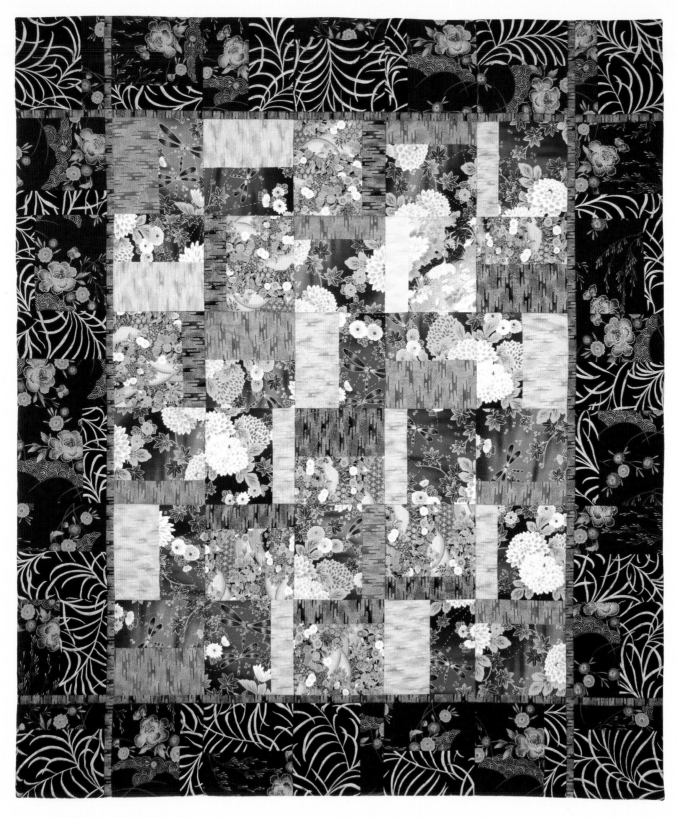

Gilded Garden

- **A double border frames the quilt top**
- **The gold overprinting on the fabrics and gold hand-stitching thread shimmer**
- **The elegant crane fabric with cream solid is the Unexpected Visitor**

MATERIALS

Patterned Fabrics

Five contemporary fabrics (44–45 inches [112–114 cm] wide): minimum ¼ yard (23 cm) for the crane pattern, minimum ½ yard (46 cm) for the three floral patterns, and minimum 1¼ yards (1.1 m) for the black border pattern.

Solid Fabrics

Five solids with gold overprinting (44–45 inches [112–114 cm] wide): minimum ¼ yard (23 cm) for the cream with mist motif, minimum ½ yard (46 cm) for the blue and red with mist motif, minimum 1½ yards (1.5 m) for the black with plume motif, and minimum 2 yards (2 m) for the black with mist motif.

MAKE YOUR QUILT TOP

Refer to the Make Your Quilt Top section at the back of the book for detailed instructions on making your quilt top.

Assemble your fabrics. Look for harmony within your palette for the central fabrics, a related fabric for the Unexpected Visitor, and a contrast fabric for the outer border. For this quilt, the block with the crane pattern and cream solid is the Unexpected Visitor.

Gilded Garden is made with fifty-six 8-inch (20-cm) blocks with five color combinations and an inset border:

- Color A (black floral pattern/black with plume motif): 26 blocks
- Color B (floral one/blue with mist motif): 11 blocks
- Color C (floral two/red with mist motif): 10 blocks
- Color D (floral three/black with mist motif): 8 blocks
- Color E (crane pattern/cream with mist motif): 1 block

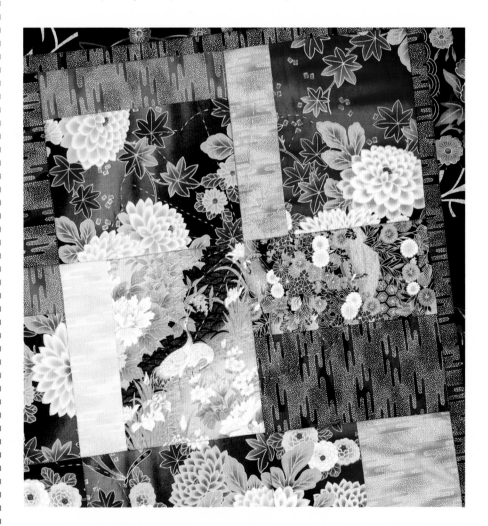

Make the Rough Blocks

The central area of Gilded Garden has 15 blocks with 1/2 patterns and 18 blocks with 3/4 patterns. All of the central area of the quilt uses blocks with the larger amount of patterns. Keep this in mind when you rough cut your patterned fabrics and solids.

The outer border has 12 blocks with 1/4 patterns, 10 blocks with 1/2 patterns, and 4 blocks with 3/4 patterns. The border blocks have the lesser amount of pattern to show off the black solid with plume motif. Keep this in mind when you rough cut the border pattern and solids.

Sew the rough blocks together and press the seams open.

Trim Out the Rough Blocks

Trim the blocks with the Cutting Dance (page 149).

Develop the Design of the Center Area

Place the trimmed blocks with the floral and crane patterns on your design wall and develop the composition for the central area. Try different configurations, and switch out extra blocks for more variations.

Assemble the Central Area of Your Quilt Top

When you are happy with the design of the central area, sew the blocks and rows together.

Develop the Design of the Outer Border

Place the assembled central area on your design wall. Place the trimmed blocks for the outer border around the central area to develop your quilt design. Make sure the rotation of the outer border blocks relates to the positioning of the central blocks.

Assemble the Outer Border

Sew together the blocks for the top and bottom rows of the outer border, without the corner blocks.

Sew together the blocks for the sides of the outer border without the corner blocks.

Precision Cut the Inner Border Fabric

Cut 1¼-inch- (3-cm-) wide strips, along the grain, of the black with mist motif solid: two strips 68 inches (173 cm) long, two 44 inches (112 cm) long, and four 10 inches (25 cm) long. Handle and press these strips carefully so they do not distort.

Add the Inner Border

Sew the 44-inch (112-cm) inner-border strips to the top and bottom of the central area of the quilt. Press the seams out. Trim the ends of the inner-border strips flush with the central area.

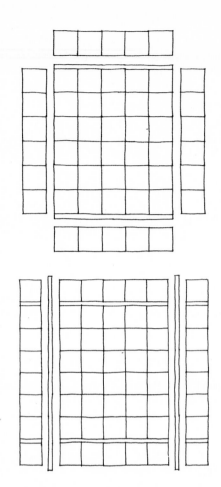

GILDED GARDEN QUILT ASSEMBLY.

THE VERTICAL INNER BORDER STRIPS ARE THE LAST DETAIL TO BE SEWN IN GILDED GARDEN QUILT TOP.

Sew the top and bottom rows of the outer border (without corner blocks) to the central area. Press the shared seams of the inner and outer borders out.

Sew the 10-inch (25-cm) inner border strips between the corner blocks and the side rows of the outer border. Press the seams out. Trim the inner border strips flush with the width of the blocks.

Sew the 68-inch (173-cm) inner border strips to both sides of the central area.

Sew the sides of the outer border to the central area, lining up the horizontal inner borders. Press the seams out.

FINISH YOUR QUILT

Refer to the Finishing Steps section at the back of the book for detailed instructions on completing your quilt.

Make Your Quilt Back

Make your quilt back whole cloth or pieced. Use what you have on hand or seek fabrics to complement or contrast your quilt top design, keeping in mind the fabrics you have available or planned for the facing. The final size should be 66 × 74 inches (167.5 × 188 cm). Press all seams open.

The back of Gilded Garden is made with 4 yards (4 m) of contemporary Japanese-style fabric (44–45 inches [112–114 cm] wide), cut into two 2-yard (2-m) lengths. Trim one length 5 inches (13 cm) on each side to yield a 33 × 72-inch (84 × 183-cm) piece. Cut the other length down the middle to yield two 22 × 72-inch (56 × 183-cm) pieces. Sew the three lengths of fabric together, with the 33-inch (84-cm) length in the center, to yield a 76 × 72-inch (192 × 183-cm) back.

Make and Sew the Quilt Sandwich

Pin baste the quilt sandwich. Stitch-in-the-ditch around the blocks to secure the quilt sandwich. Stitch-in-the ditch on both sides of the inner border too. Keep the basting pins around the perimeter instead of tailor basting.

Design and Mark Your Hand-Stitching Pattern

Look at your quilt front and back fabrics to inspire your stitching pattern. The hand-stitching on Gilded Garden is fashioned after the Japanese imperial chrysanthemum *kamon* or family emblem. The symmetry of a central flower medallion with four flower medallions in each quadrant adds to the traditional quality of the border design.

For the medallion stitching patterns, cut out five pieces of freezer paper: one 18-inch (46-cm) square and four 12-inch (30.5-cm) squares. With the shiny side of the freezer paper in, fold each square in half, corner to corner, then in half again, then in half again, and then a final fold in half. For each fold, score with a bone folder or fingernail to create the thinnest edge possible; otherwise, the paper gets too bulky at the point. (This will remind you of the magic of making paper snowflakes as a kid.)

Cut a curved scallop at the wide end of the folded freezer paper. Trim ½ inch (1.5 cm) off the point. Open up.

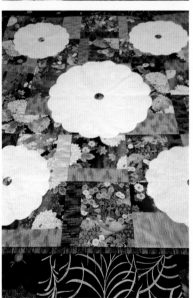

MAKE CHRYSANTHEMUM MEDALLIONS FROM FREEZER PAPER AND IRON ONTO THE TOP OF GILDED GARDEN FOR THE STITCHING PATTERN.

Position the paper medallion patterns on your quilt top where the folds in the paper line up with the block seam lines. Iron your stitching patterns onto the quilt top. Trace around the edges and center circle with a water-soluble blue marking pen or white chalk pencil. Use your grid ruler to add additional stitching lines that radiate from the center of medallions to the center of each scallop.

Hand Stitch Your Quilt

Hand stitch, following the blue or white lines. Gilded Garden is stitched with 8 wt. braided gold thread, which is more delicate than perle cotton. Be careful not to break the thread when you tug on a knot to pop it into the quilt sandwich. If there is resistance, roll the knot between your fingers to make it smaller, then try again.

Block and Trim Your Quilt

Block your quilt (see page 179), if you like. Trim your quilt and staystitch the perimeter of the quilt.

Make and Add the End Cap Facing

Refer to End Cap Facings (page 183) for detailed instructions on making and sewing on a facing.

The double-thick facing for Gilded Garden is made with ¼ yard (23 cm) of floral fabric for the corner blocks, 1¾ yards (1.6 m) of the black with gold plume for the outer border, and 1¾ yards (1.6 m) of the black with mist motif for the inner border. The final facing is 3⅞ inches (4 cm) wide.

Cut the fabric for the corner blocks into four 4½ × 11½-inch (11.5 × 29-cm) pieces. Cut the outer border fabric in four 5½ × 58-inch (14 × 147-cm) strips, along the grain. Cut the inner border fabric into four 6½ × 58-inch (16.5 × 147-cm) strips and four 1⅛ × 11½-inch (2.8 × 29-cm) strips, along the grain. Sew together the long strips of the two fabrics with a ¼-inch (6-mm) seam allowance and press the seams open.

Press the double strips together down their lengths with ⅝ inch (1.5 cm) of the inner border fabric showing on the outer border side.

Trim two double strips to 48½ inches (123 cm). Open the double strips and sew the short inner border strips and corner block pieces to the ends. Press all seams open. Press the two double strips lengthwise on the earlier press line.

Trim all facing strips to 4⅛ inches (10 cm) wide. Trim the side facing strips without the end blocks to 60 inches (152 cm) long.

Position the facing strips on the front of the quilt, right side down. Place the strips with corner blocks on the top and bottom. Place the two remaining strips on the sides, overlapping the top and bottom facing strips. Make sure the inner border on the side strips aligns with the inner border pieced into the top and bottom facing strips.

Stitch on the strips with a ¼-inch (6-mm) seam allowance and turn to the back for a 3⅞-inch- (9.5-cm-) wide finished facing. Use thread matching the inner border fabric for the invisible stitching.

Final Details

Name your quilt and add a label.

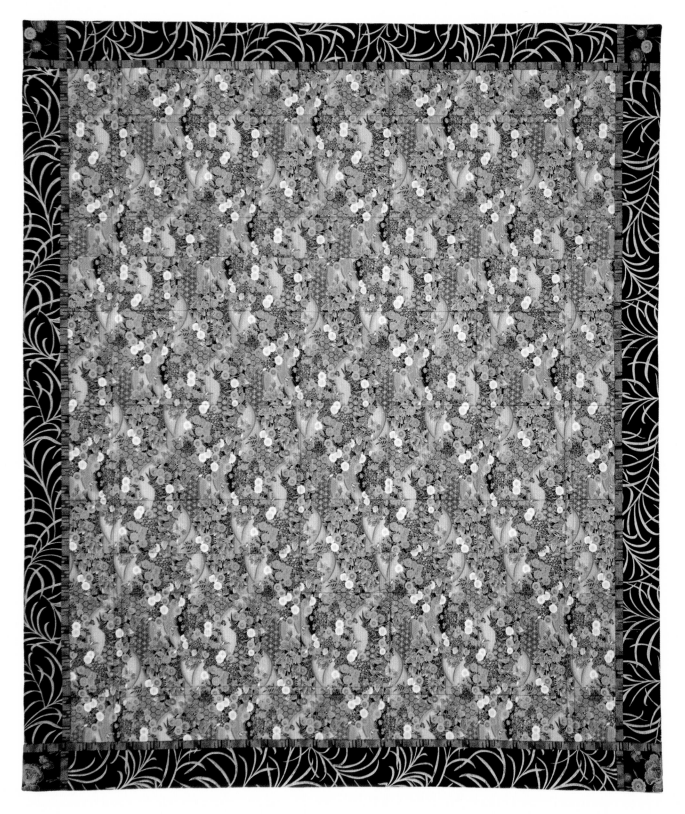

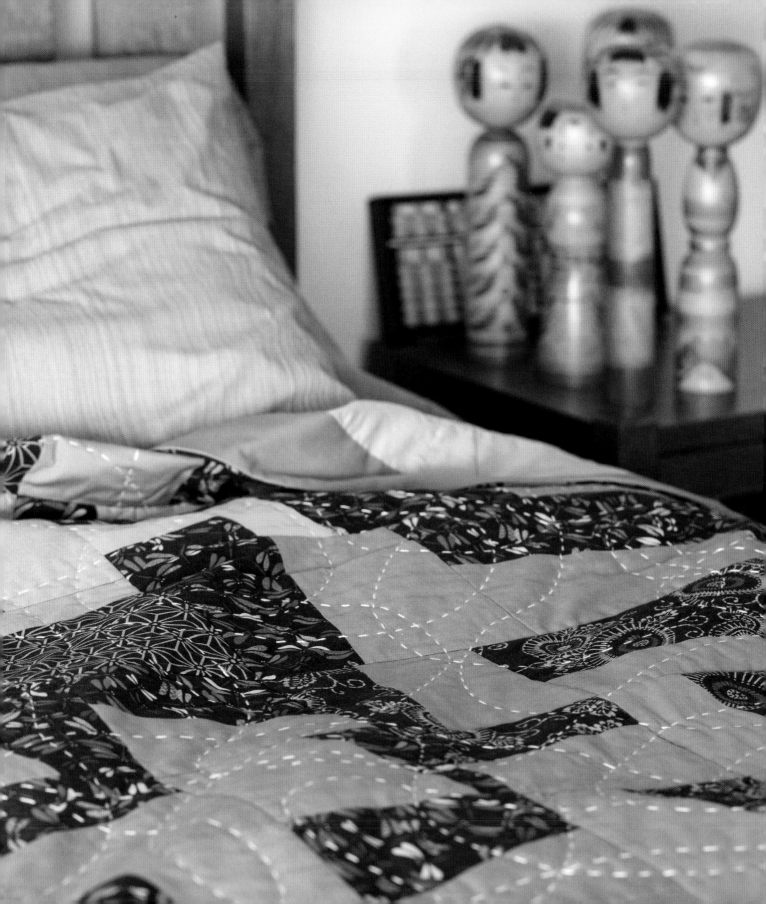

Yin Yang

Angled Cuts

The Chinese concept of yin *and* yang *was introduced in Japan at the beginning of the sixth century. The duality of yin and yang represents perfect balance with two contrary forces complementing each other to become a greater whole.*

Yin Yang looks more complicated than it really is. Three navy fabrics printed with petite Japanese motifs create an overall background. With an angled seam in each block, complex forms emerge from the conjoined angled solids. Breaking down the design, you can recognize the fluctuating nine-patch layout. Different-size blocks fill the 24-inch (61-cm) squares—the largest are 8 inches (20 cm), the midsize are 6 inches (15 cm), and the tiny ones are 4 inches (10 cm). You will find hand quilting with big stitches exhilarating. Not only does the task get done in half the time, but stitching along the ebullient loopy lines feels completely liberating. The oversize stitching also has a guaranteed wow factor.

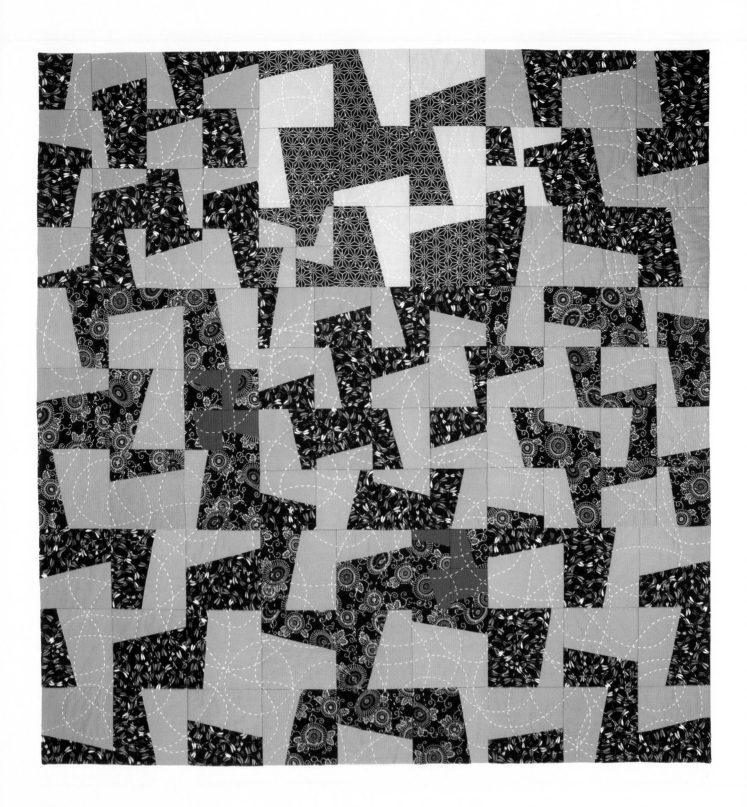

Yin Yang

FINISHED QUILT MEASURES
72 × 72 INCHES (183 × 183 CM)

- - - - - - - - - -

- **The block sizes range from 4 inches (10 cm) to 6 inches (15 cm) to 8 inches (20 cm) square**
- **Turquoise, bright yellow, and rust Unexpected Visitors land like ninja stars**
- **Big stitch quilting in an unpredictable design adds an animated detail**

- - - - - - - - - -

MATERIALS

Patterned Fabrics

Three contemporary fabrics (44–45 inches [112–114 cm] wide): minimum ½ yard (46 cm) for the hemp stars, minimum 1½ yards (1.5 m) for the flowers, and minimum 2½ yards (2.5 m) for the dragonflies.

Solid Fabrics

Six solids (44–45 inches [112–114 cm] wide): minimum 10 × 10-inch (25 × 25-cm) scrap of turquoise and bright yellow, minimum ¼ yard (23 cm) for the rust, minimum ½ yard (46 cm) for the oat, minimum 1½ yards (1.5 m) for the ochre, and minimum 2½ yards (2.5 m) for the blue.

MAKE YOUR QUILT TOP

Refer to the Make Your Quilt Top section at the back of the book for detailed instructions on making your quilt top.

Assemble your fabrics. Look for three patterned fabrics with small overall designs and similar background colors, a palette of three main solids that work well together, and three contrast solids. The small bright yellow, turquoise, and rust blocks are the Unexpected Visitors.

Yin Yang is made with nine 24-inch (61-cm) squares with three block sizes. Square elements, from top left across to right:

Square 1 • Color A (dragonflies/blue): sixteen 6-inch (15-cm) blocks

Square 2 • Color B (hemp stars/oat): eight 8-inch (20-cm) blocks
• Color C (hemp stars/turquoise): four 4-inch (10-cm) blocks

Square 3 • Color A (dragonflies/blue): eight 8-inch (20-cm) blocks
• Color D (dragonflies/bright yellow): four 4-inch (10-cm) blocks

Square 4 • Color E (flowers/ochre): eight 8-inch (20-cm) blocks
• Color F (flowers/rust): four 4-inch (10-cm) blocks

Square 5 • Color A (dragonflies/blue) sixteen 6-inch (15-cm) blocks

Square 6 • Color E (flowers/ochre): sixteen 6-inch (15-cm) blocks

Square 7 • Color A (dragonflies/blue): nine 8-inch (20-cm) blocks

Square 8 • Color E (flowers/ochre): eight 8-inch (20-cm) blocks
• Color F (flowers/rust): four 4-inch (10-cm) blocks

Square 9 • Color A (dragonflies/blue): nine 8-inch (20-cm) blocks

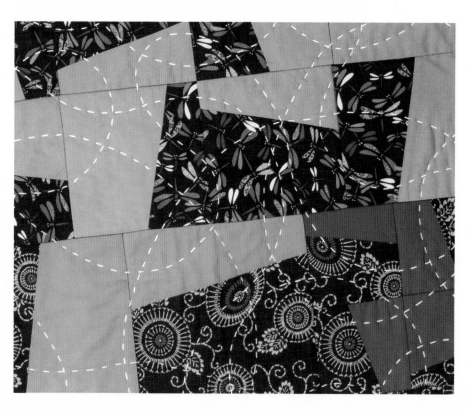

Make the Rough Blocks

Although Yin Yang has square blocks with a pattern and solid, the rough and final cutting of the blocks is completely different than for other Hachi Quilts. None of the angles are measured. Cut the fabric on an angle by eye and vary the location of the angle. Be sure to cut both left- and right-heading angles across the squares.

For 8-inch (20-cm) blocks, rough cut 9½-inch (24-cm) squares of patterns and solids. For 6-inch (15-cm) blocks, rough cut 7½-inch (19-cm) squares of patterns and solids. For 4-inch (10-cm) blocks, rough cut 6-inch (15-cm) squares of patterns and solids.

Stack a pattern square on top of a solid square and cut at an angle. Pair the top left pattern piece with the bottom right solid. Pair the top right pattern piece with the bottom left solid.

Be sure to manage the pairs of cut fabric—flip the patterned piece on top of its paired solid and keep the two pieces together until you are ready to sew them.

Sew the blocks together along the angled cut with ¼-inch (6-mm) seam allowances. Press the seams open.

Trim the Rough Blocks

Using your grid ruler, trim the rough blocks. For 8-inch (20-cm) final blocks, use the Cutting Dance (page 149) to trim the rough blocks to 8½ inches (21.5 cm) square. For 6-inch (15-cm) final blocks, trim the rough blocks to 6½ inches (16.5 cm) square. For 4-inch (10-cm) final blocks, trim the rough blocks to 4½ inches (11.5 cm) square.

Develop the Design

Place the trimmed blocks on your design wall to develop the composition of your quilt top with nine big squares.

The solid elements of the blocks make compelling shapes when connected. Keep rotating the bigger blocks and trying out positions for the 4-inch (10-cm) quartet blocks until you are satisfied with your design.

Assemble Your Quilt Top

Sew the 4½-inch (11.5-cm) blocks together. First sew the top two blocks together and press the seam allowances to the left. Then sew the bottom two blocks together and press the seam allowances to the right. Then sew the horizontal seam between the two sets of blocks. The quartet of blocks should be 8½ inches (21.5 cm) square.

Number the rows of each 24-inch (61-cm) square

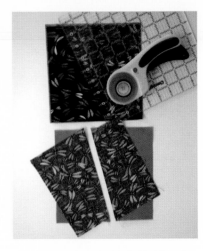

STACK THE ROUGH-CUT PATTERNED AND SOLID SQUARES ON TOP OF ONE ANOTHER AND CUT THEM ON AN ANGLE. THEN FLIP OVER THE PATTERNED SQUARES AND PAIR THEM UP WITH THE SOLID SQUARES ON THE OPPOSITE SIDES.

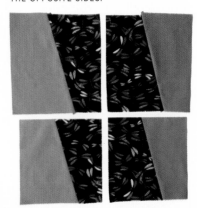

SEW THE ROUGH BLOCKS TOGETHER, PRESS THE SEAMS OPEN, AND TRIM THE BLOCKS TO THE DESIRED SIZE.

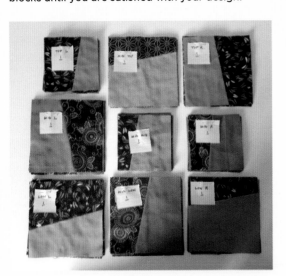

(LEFT) THE BLOCKS FOR EACH SQUARE, STACKED AND READY TO SEW TOGETHER.

separately. For example, the rows of the top-left square can be labeled Top-L 1, Top-L 2, and Top-L 3. The rows of the top-middle square can be labeled Mid-Top 1, Mid-Top 2, and Mid-Top 3. Use any system that makes sense to you; just make sure you label every row of every square.

Stack up the blocks for every square. Sew each 24-inch (61-cm) square separately. First sew the blocks together into rows, then sew the horizontal rows together.

Sew the top three squares together. Sew the middle three squares together. Sew the bottom three squares together. Finish by sewing the horizontal seams between the three sets of squares.

ONCE THE DESIGN IS COMPLETE, ADD LABELS TO EVERY ROW IN ALL NINE SQUARES.

SEW TOGETHER THE BLOCKS IN EACH 24-INCH (61-CM) SQUARE BEFORE YOU ASSEMBLE THE WHOLE QUILT TOP.

FINISH YOUR QUILT

Refer to the Finishing Steps section at the back of the book for detailed instructions on completing your quilt.

Make Your Quilt Back

Make your quilt back whole cloth or pieced. Use what you have on hand or seek fabrics to complement or contrast your quilt top design, keeping in mind the fabrics you have available or planned for the facing. The final size should be 80 × 80 inches (200 × 200 cm). Press all seams open.

The back of Yin Yang is made with eight fabrics: ¾ yard (69 cm) of yellow and navy; 1 yard (1 m) of hemp stars, oat, turquoise, and blue; 2 yards (2 m) of beige; and an additional ¼ yard (23 cm) of extension fabric (see page 181). Cut all the fabrics at an angle, except the lower horizontal seam, to play off the design of the quilt front. Sew the fabric together as three big horizontal pieces. The position of the navy, flowing from the top area to the center area, adds drama to the design.

Make and Sew the Quilt Sandwich

Pin baste the quilt sandwich. Stitch-in-the-ditch around the blocks to secure the quilt sandwich. Tailor baste around the perimeter.

Design and Mark Your Hand-Stitching Pattern

Look at your quilt front and back fabrics to inspire your stitching pattern. The hand-stitching pattern on Yin Yang is dubbed The Flight of the Dragonfly, named after the dragonfly pattern in the Japanese fabric on the quilt front.

To start, hand draw big loopy shapes all over the quilt top with a water-soluble blue marking pen. Add smaller loops and curved lines. Whenever possible, deliberately manipulate intersections of the lines to cross in the solids.

Hand Stitch Your Quilt

Hand stitch, following the blue lines. I stitched Yin Yang using no. 5 perle cotton with big ¼-inch (6-mm) stitches. After you stitch the first set of blue lines, draw more lines onto the quilt and stitch. The more you stitch, the better the quilt looks.

Block and Trim Your Quilt

Block your quilt (see page 179), if you like. Trim your quilt and staystitch the perimeter of the quilt.

Make and Add the End Cap Facing

Refer to End Cap Facings (page 183) for detailed instructions on making and sewing on a facing.

The double-thick facing for Yin Yang is made with leftovers from the quilt project. Working with 8-inch- (20-cm-) wide scraps of fabric, piece long strips together with all the seams pressed open. Once you have two 72-inch- (183-cm-) long and two 68-inch- (172-cm-) long strips, press the strips lengthwise and trim to 3¼ inches (8 cm) wide.

Position the facing strips, right side down, on the quilt front. Pin the two 72-inch (183-cm) strips across the width of the quilt sandwich at the top and the bottom. Pin the two 68-inch (173-cm) strips on each side of the quilt sandwich on top of the top and bottom strips.

Stitch on the strips with a ¼-inch (6-mm) seam allowance and turn to the back for a 3-inch- (7.5-cm-) wide finished facing. Use thread matching each facing fabric for the invisible stitching.

Final Details

Name your quilt and add a label.

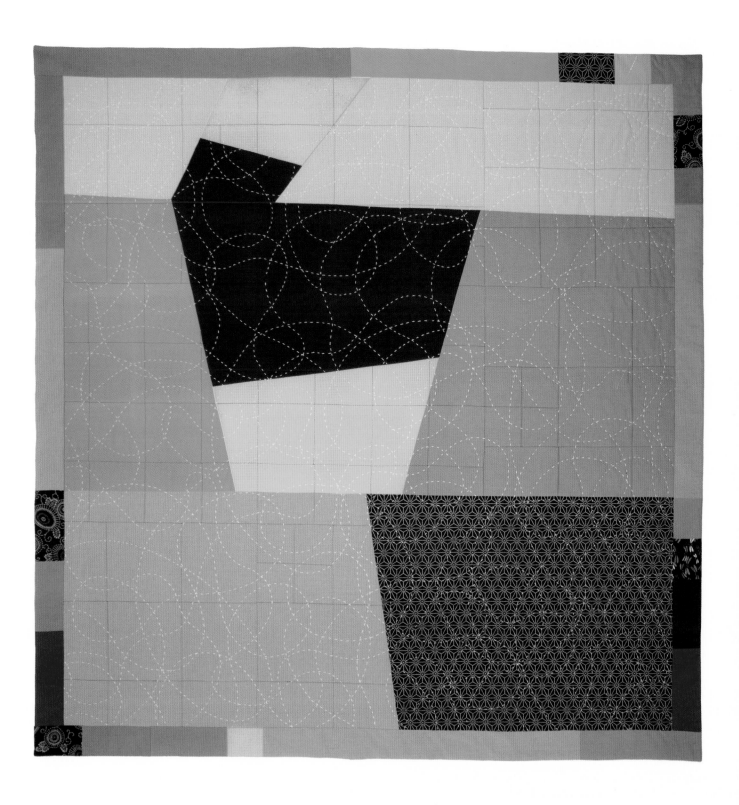

Make Your Quilt Top

Tools for Quilt Making

ESSENTIALS FOR MAKING HACHI QUILTS

8½ x 24-inch (21.5 x 61-cm) Grid Ruler
You need this size ruler for making 8-inch (20-cm) quilt blocks that require no measuring.

11½-inch (29-cm) Suction Grip Handle
This handle with two suction cups is used in the Cutting Dance to trim out your blocks accurately. You will never regret buying this simple tool. It is indispensable for cutting fabric with any of the bigger grids.

Design Wall

You use your design wall to develop your quilt composition. Instead of viewing your quilt progress on a table, bed, or floor, you can stand back from the design wall, move blocks around with no pinning, and leave your composition overnight while you consider what to try next.

The most basic design wall is a piece of flannel pinned, tacked, or taped to a wall. Other versions include wrapping flannel or batting around a board. My favorite is an inexpensive 60 × 72-inch (152 × 183-cm) portable design wall made with vinyl-backed flannel, printed with a grid, and ready to hang with grommets. I hang mine with teacup hooks.

Cotton with Scrim Batting

Use this specialty batting, a low-loft natural material with a grid of polyester scrim that allows for stitching 10 inches (25 cm) apart—perfect for Hachi Quilts.

THE BASICS

Rotary Cutter

You use a rotary cutter to easily cut straight across your fabrics. I suggest a 60mm rotary cutter—the biggest blade size available. You can cut quickly through many layers or seams with ease. All rotary cutters have a safety lock, so be sure to leave your cutter locked when not in use. If you have to saw back and forth to cut your fabric, your blade is dull. Replacement blades are always less expensive if you buy a multipack.

Cutting Mat

You cut fabric with your rotary cutter on a self-healing mat. You want the 24 × 36-inch (61 × 91-cm) size, as the big cutting surface is helpful when you trim your quilt. If your mat gets dusty or linty, wipe it with a damp cloth. Do not let anyone put a hot drink on your mat or it will warp.

Quilting Grid Rulers

If you are a beginning quilter, you need to buy at least one grid ruler. (Experienced quilters usually have a library of rulers.) These see-through measuring tools are printed with a grid. It's best to get ones that include ⅛-inch (3-mm) increments. To use, lay the grid ruler across your fabric aligned with a needed measurement. Then pull your rotary cutter along the edge of the ruler to get a perfectly cut piece of fabric.

Scissors

Good scissors are a joy, while cheap scissors are a misery. Be sure to buy the best fabric scissors you can afford. You also need a small pair of snips to cut threads and a pair of scissors only for freezer paper.

Steam Iron and Ironing Board

Make sure you have an iron that can get hot and deliver steam for pressing your project during production. A travel iron is great for classes away from home, but be sure to

GOOD SCISSORS ARE A SMART INVESTMENT.

get a full-size iron for your sewing space. Your ironing board needs to raise to a height that is good for you and your back. Make sure the padded cover is secured and taut so the ironing surface lies flat.

Sewing Machine

All you need for sewing Hachi Quilts is a sewing machine that sews straight lines and has a walking foot attachment. It's ideal if your machine has a ¼-inch (6-mm) presser foot so you can sew your seams by aligning the edge of your fabrics with the edge of the presser foot.

Walking Foot

You need this attachment for sewing your quilt sandwich together. It provides a top set of feed dogs to move the fabric sandwich through your sewing machine in sync with the lower feed dogs. You will use your walking foot for staystitching around the quilt, stitching-in-the-ditch, and attaching your facing.

Fine Pins and Pincushion

Pins secure fabric layers together. For sewing your quilt, you want glass-headed fine, sharp pins. Be sure to get the best pins—they cost only pennies more and you will use them for a lifetime. A pincushion is useful for quickly grabbing your pins.

Seam Ripper

Ripping out seams is an inevitable part of creating. Choose a ripper with a handle that feels good to hold. The C-shaped head of your seam ripper should have a sharp point on the long side and a blade-like edge on the inner curve. You will collect a few seam rippers over time, which is great—then you can find one whenever you need it.

Sewing Machine Needles

Your sewing machine needle, not your sewing machine, determines the quality of your stitches. Buy quality brand-name needles to avoid hassles with stitching problems. For all the production steps of Hachi Quilts, use a quilting or microtex sharp needle. A 70/10 or 75/11 needle is a good match for 50 wt. quilting thread. Avoid universal needles.

Hand Sewing Needles

Choose a hand sewing needle that matches your task and fabric. For tailor basting and sewing on the facing, use a sharp. For hand quilting, use a sashiko needle.

Threads

For piecing and general sewing, I recommend 50 wt. cotton thread. Light, medium, and dark gray threads are good standards to use. For stitching-in-the-ditch, use 50 wt. cotton thread in a color that matches your quilt fabrics. For hand quilting, use no. 8 perle cotton. For big stitching, choose heavier no. 5 perle cotton.

Thimble

A thimble protects your middle finger as you push the needle through the quilt

MY STEADFAST PINCUSHION, LILYBELLE.

COTTON THREAD IS IDEAL FOR PIECING QUILT TOPS AND STITCHING-IN-THE-DITCH.

sandwich when hand quilting. I use a coin thimble made of soft leather that some Japanese quilters recommended. Look for a thimble that suits you.

Quilting Basting Pins and Pin Basting Tool

Use curved safety pins for pin basting the quilt sandwich in the finishing stage of your quilt. One 300-count package is plenty. For closing the pins and avoiding pricked fingers, use a Kwik Klip, grapefruit spoon, or screwdriver.

Freezer Paper

This paper has a matte side that you can draw on and a shiny side that adheres lightly to fabrics when heated with an iron. Look for freezer paper in your grocery store with the food wraps.

Marking Tools

You want to temporarily mark your fabrics with your stitching designs. For general marking, a blue water-soluble pen is a good choice. For dark-colored fabrics, a compressed chalk pencil is excellent for marking lines that hold up to lots of handling.

Point Turner

Once you sew the facing onto your quilt front, you need to turn it to the back. A point turner pushes out the corners.

OPTIONAL TOOLS

Task Light

Your sewing machine has a light so you can see your work readily. Add a task light to brighten your workspace.

Compression Grip Gloves

Made of cotton and spandex with polyvinyl dots along the fingers, these gloves give you a good grip on your quilt while guiding it through your sewing machine. I didn't use grip gloves for five years, but now I can't live without them!

Medium-Weight Pins

You need sturdy pins if you choose to block your quilt. Choose Size 20 ball point pins or something similar with a glass bead on top.

4-Foot (1.25-m) T-Square

You use the T-square for trimming out your quilt before adding a facing. You can substitute your 24-inch (61-cm) grid ruler for this step, but the longer the edge, the better.

Tailor's Clapper

This hardwood tool is excellent for pressing the final edge of your quilt after you have added the facing. First press the edge with steam, then immediately place the clapper over the same area and apply even pressure. Your quilt edge will be flat and crisp, with no shine.

THE SPEARS OF BASTING PINS ARE SLIGHTLY BENT.

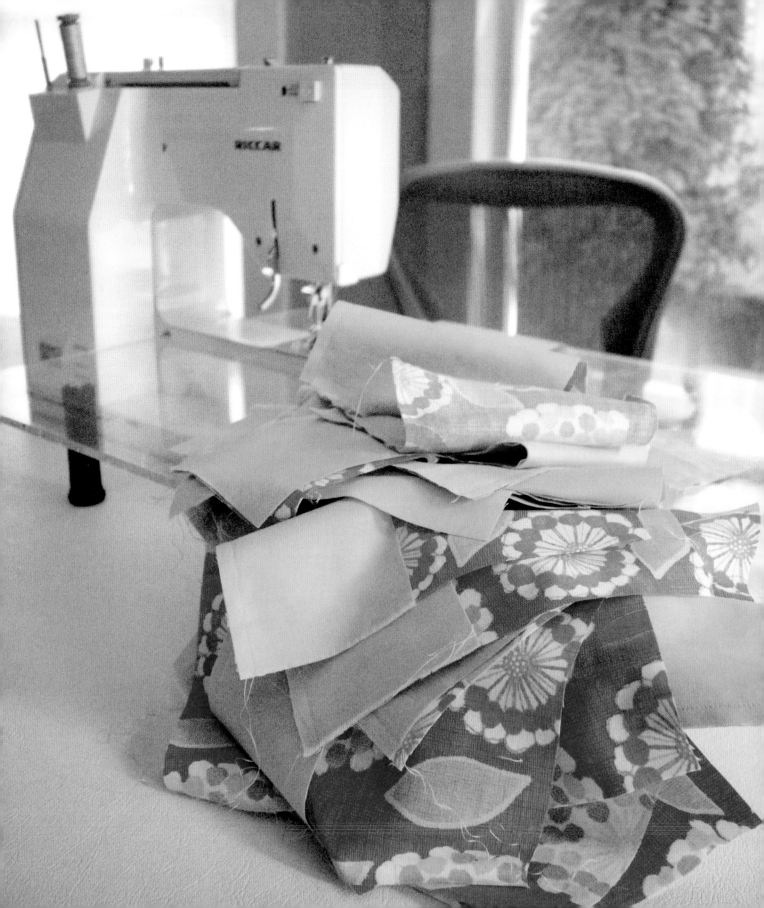

Make the Rough Blocks

Assemble your fabrics. These three words sound so simple, but this very first step defines your whole quilt project. Be sure to have ample yardage to try out different fabric combinations during your design development.

Rough Cut Your Fabrics

This is not a precision step. Your pieces can be slightly larger than directed. For experienced quilters, this step may seem extraneous. Why not cut the required fabric pieces to the exact size? The answer: This approach is helpful when cutting up specialty fabrics to capture the fussy parts. Also, you will be trimming the blocks without measuring using the Cutting Dance—a fun way to get the job done and keep your creative juices flowing.

When using contemporary fabrics, cut across the width to make 9-inch (23-cm) high strips. Then cut the 9-inch- (23-cm-) high strips into various widths to make the three Hachi Quilt block combos:

Block Style A: 1/4 pattern + 3/4 solid
Rough cut a 3-inch- (7.5-cm-) wide strip of pattern + a 7-inch- (18-cm-) wide strip of solid

Block Style B: 1/2 pattern + 1/2 solid
Rough cut a 5-inch- (13-cm-) wide strip of pattern + a 5-inch- (13-cm-) wide strip of solid

Block Style C: 3/4 pattern + 1/4 solid
Rough cut a 7-inch- (18-cm-) wide strip of pattern + a 3-inch- (7.5-cm-) wide strip of solid

Cut the patterned fabrics first. Cut as many 3-, 5-, and 7-inch- (7.5-, 13-, and 18-cm-) wide pieces as you think you might want. There is a randomness to this rough cutting step that affects the look of your final design.

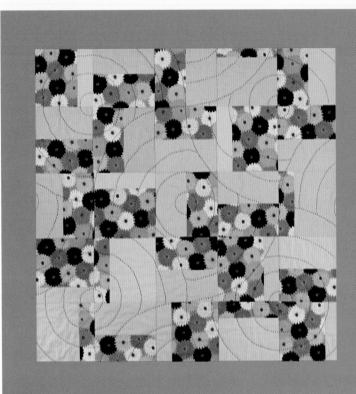

KIKU

Basic Hachi Quilt layout

Finished quilt measures
40 × 40 inches (101 × 101 cm)

Follow Kiku as it leads you through all the process steps for making your own Hachi Quilt. The simple design of this tutorial quilt makes it easy for you to see each step clearly.

Make a count of the patterned block pieces so you know how many of the matching solids you need. For example, if you have four 3-inch (7.5-cm) strips of a pattern, you will need four 7-inch (18-cm) strips of its matching solid. If you have four 5-inch (13-cm) strips of a pattern, you will need four 5-inch (13-cm) strips of its matching solid.

I generally cut up most of my fabric for Block Style C, 7-inch- (18-cm-) wide pieces of my patterned fabrics with 3-inch- (7.5-cm-) wide pieces of my solids, to get lots of the patterns showing in my quilt.

SEW TOGETHER THE ROUGH BLOCKS

With right sides together, sew the two paired pieces with ¼-inch (6-mm) seam allowances. You will be trimming all edges of the block (see page 179), so no need to start or end with reverse stitching. Also, you do not need to pin the pieces together—instead, neatly place them on top of each other and guide them through the presser foot together.

Press the Seams Open
Press the seam open within each rough block. This open-seam pressing gives an even height of fabric across the block for a flat, graphic look.

OPPOSITE:
(TOP LEFT) COLLECT FABRICS FOR THE QUILT PROJECT.

(TOP RIGHT) CUT PATTERNED FABRICS AND SOLIDS INTO 9-INCH (23-CM) HIGH STRIPS.

(BOTTOM LEFT) CUT THE 9-INCH (23-CM) STRIPS INTO VARIOUS WIDTHS FOR MAKING ROUGH BLOCKS.

(BOTTOM RIGHT) THESE ARE ROUGH-CUT FABRICS FOR MAKING BLOCKS WITH 1/4 PATTERNED FABRICS AND 3/4 SOLIDS.

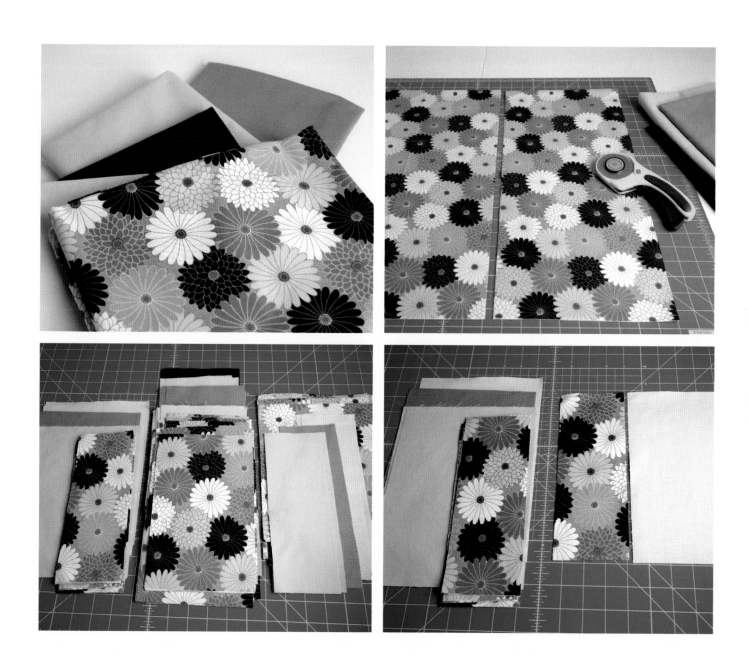

Working with Yukata Cottons

A TIME TO BE FEARLESS

It is easy to think that yukata cottons are too awesome to cut up, or that they are just perfect for wall hangings. But these thoughts will not help you begin your Hachi Quilt project.

Working with yukata cottons is different than using contemporary printed fabrics. Follow the photos and instructions on the facing page as you make your first cuts. Then revel in handling these choice Japanese fabrics and making a truly singular quilt.

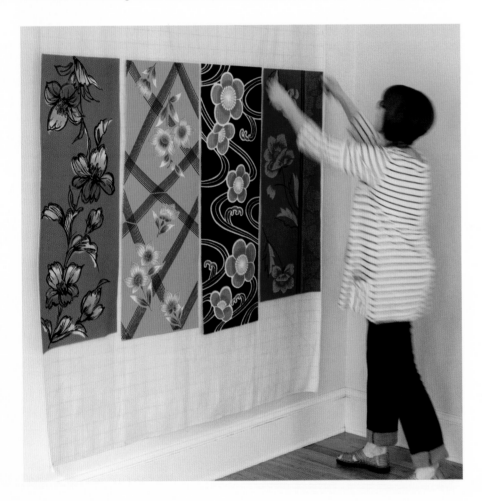

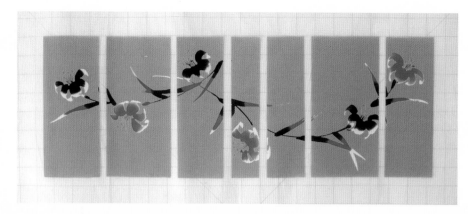

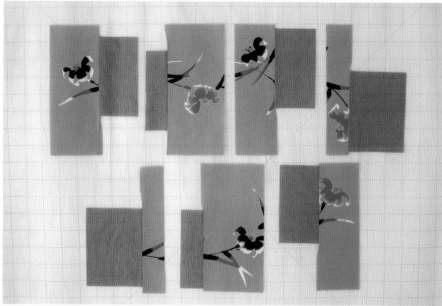

(TOP) TO START, MAKE VERTICAL CUTS ACROSS THE YUKATA COTTON TO CAPTURE THE DESIRED PARTS OF THE PATTERN. YOU WANT THE VERTICAL STRIPS TO BE 3, 5, AND 7 INCHES (7.5, 13, AND 18 CM) OR SLIGHTLY WIDER.

(MIDDLE) PAIR YUKATA COTTON STRIPS WITH SOLIDS. THE YUKATA COTTON STRIPS ARE 14 INCHES (35.5 CM) HIGH AND THE SOLIDS ARE ROUGH CUT TO 9 INCHES (23 CM) HIGH, HENCE THE UNEQUAL HEIGHTS. PLACE A SOLID BESIDE THE DESIRED PART OF A YUKATA COTTON STRIP. IF YOU WANT, FLIP THE HAND-DYED YUKATA COTTON TO REVERSE THE DIRECTION OF THE PATTERN. SEW THE TWO PIECES TOGETHER TO MAKE A ROUGH BLOCK, THEN PRESS THE SEAM OPEN.

(BOTTOM) USING THE CUTTING DANCE, CUT OFF ALL THE SIDES OF THE ROUGH BLOCKS TO MAKE TRIMMED BLOCKS READY TO USE IN YOUR QUILT TOP DESIGN.

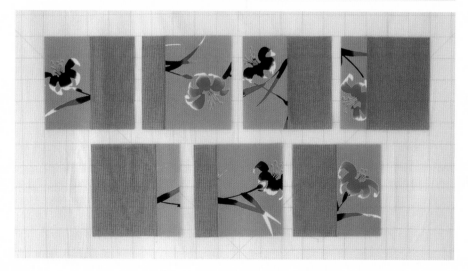

The Cutting Dance

The Cutting Dance trims rough blocks to 8½ inches (21.5 cm) square. Once you get into the swing of this step, it's fast, easy, and accurate.

The Cutting Dance precision trims your rough blocks after you stitch and press them. Looking through the grid ruler, you can capture the part of each patterned fabric that you like best. Once set up, it takes less than 5 seconds to trim a rough block.

Trim Block Style A: 1/4 + 3/4 Configuration Rough Blocks

- Place your cutting mat in the corner of a regular-height table.
- Stand at the corner of the table with the mat in front of you.
- Place a 1/4 + 3/4 rough block on the cutting mat, right side up, with the narrower 1/4 piece on your right.
- Align the rough block on the mat so its edges are parallel to the edges of the table and not at an angle.
- Attach the suction grip handle to the left side of the grid ruler so you can see the 2¼-inch (6-cm) vertical grid line.
- Place the ruler with handle on top of your rough block, positioning the 2¼-inch (6-cm) grid line on top of the seam (make sure the length of the ruler is centered on your rough block so the ruler doesn't spin when you trim).
- With your left hand, press down on the suction grip handle to secure the rough block.
- With your right hand, cutting away from yourself, roll your rotary cutter along the right edge of the ruler to trim excess fabric.
- Do not let go of the suction grip handle, and maintain pressure on the handle and rough block so they do not shift.
- Step to the right, around the corner of the table: Your left hand may slide slightly along the suction grip handle, but nothing should move.

- With your right hand, cutting away from yourself, roll your rotary cutter along the far edge of the ruler to trim excess fabric.
- Pull the grid ruler off the rough block.
- Rotate the rough block 90 degrees and place it back down in the same corner of the cutting mat.
- Again, stand at the end of the table by the right corner.
- Place the ruler with handle on top of your rough block, aligning horizontal grid lines with the top and bottom of your rough block (make sure the length of the ruler is centered on your rough block so the ruler doesn't spin when you trim).
- With your left hand, press down on the suction grip handle to secure the rough block.
- With your right hand, cutting away from yourself, roll your rotary cutter along the right edge of the ruler to trim excess fabric.
- Do not let go of the suction cup handle and maintain pressure on the handle and rough block so they do not shift.
- Step to the right, around the corner of the table: Your left hand may slide slightly along the suction grip handle but nothing should move.
- With your right hand, cutting away from yourself, roll your rotary cutter along the far edge of the ruler to trim excess fabric.

Trim Block Style B: 1/2 + 1/2 Configuration Rough Blocks

Follow the above instructions, but attach the suction grip handle on the far left side of the grid ruler so you can see the 4¼-inch (11.5-cm) vertical grid line. For the first set of trims, place the ruler with handle on top of your rough block, positioning the 4¼-inch (11.5-cm) grid line on top of the seam, and proceed per Block Style A instructions.

Trim Block Style C: 3/4 + 1/4 Configuration Rough Blocks

Follow the instructions for Block Style A, but place a 3/4 + 1/4 rough block on the cutting mat, right side up, with the narrower solid piece on your right, and proceed per Block Style A instructions.

THE GRID RULER IS POSITIONED FOR CUTTING A 1/2 + 1/2 BLOCK WITH THE 4¼-INCH (10.75-CM) MARK PLACED EXACTLY OVER THE BLOCK SEAM.

Production Tip

Trim all your rough blocks with the 1/4 + 3/4 and 3/4 + 1/4 configurations at the same time. Then reattach the suction grip handle further to the left on the grid ruler for trimming the rough blocks with the 1/2 + 1/2 configuration.

OPPOSITE:
(TOP LEFT) WHILE STANDING AT THE END OF THE TABLE, MAKE THE FIRST CUT ALONG THE RIGHT SIDE.

(TOP RIGHT) AFTER STEPPING AROUND TO THE SIDE OF THE TABLE, MAKE THE SECOND CUT ALONG THE LEFT SIDE.

(BOTTOM LEFT) AFTER STEPPING BACK TO THE END OF THE TABLE, ROTATE THE BLOCK, REALIGN THE GRID RULER, AND MAKE THE THIRD CUT ALONG THE THIRD SIDE OF THE BLOCK.

(BOTTOM RIGHT) AFTER STEPPING AROUND TO THE SIDE OF THE TABLE, MAKE THE FOURTH CUT ALONG THE LAST SIDE OF THE BLOCK.

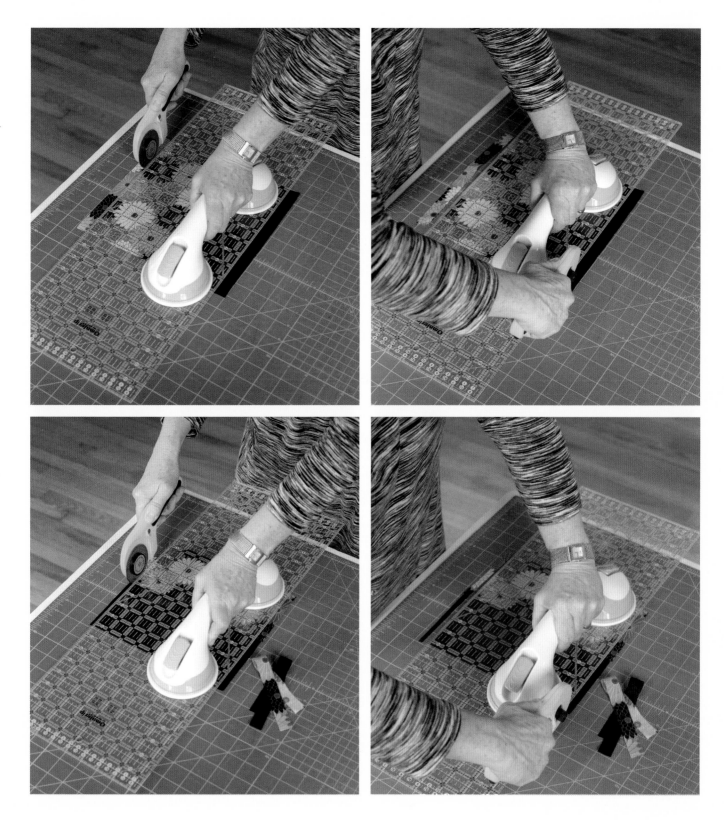

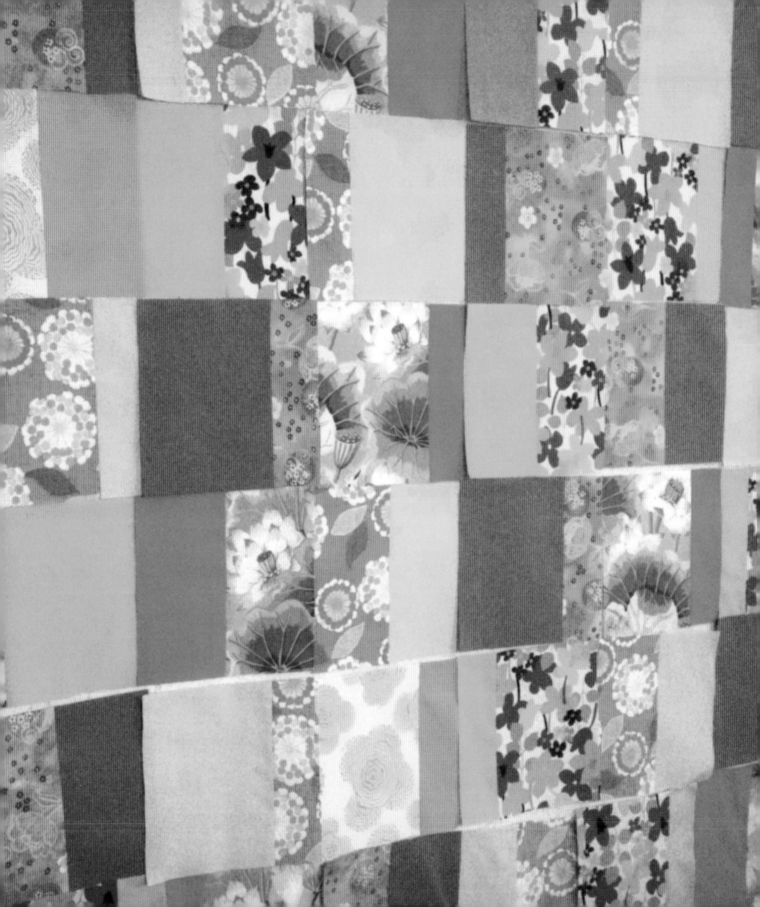

Developing Your Design

Make piles of similar colors and configurations of trimmed blocks so they are organized and handy as you design your quilt top.

- Starting at the top left corner of your design wall, place one of your trimmed blocks with the seam vertical.
- Place another trimmed block beside the first, with the seam horizontal.
- Continue placing vertical and horizontal trimmed blocks across the design wall until you have as many as blocks as you want for the width of your quilt.
- Move to the second row, starting below the first placed block, and place a trimmed block with the seam horizontal at the beginning of the second row.
- Place another trimmed block beside the first with the seam vertical.
- Continue placing horizontal and vertical trimmed blocks until the end of the second row.
- Continue making all desired rows.

BRILLIANT NEXT STEPS

As you place your trimmed blocks on your design wall, focus on the relationships that are forming between adjacent blocks and on the design as a whole. Do you want to spread out similar block configurations so they don't clump in one area? Do you want to group matching blocks together for impact? What about the Unexpected Visitor?

Take a photo of your composition with your smartphone and see how it looks small. This may help you make minor adjustments to the layout. You may also feel frustrated because all the quilt blocks aren't coming together as you had originally anticipated. This is common among improv quilters who are developing something new by process design.

Take a break. Come back to your project with a fresh eye and an eagerness to make bold changes. Don't hang on to your earlier idea if it isn't working. Use this opportunity to leapfrog what is right in front of you to a new concept. The key is to be discerning during every step of your project. Take a look at what you are doing to see how your choices impact the overall design. Continually use a critical eye to review your work.

LET YOUR INTUITION LEAD THE CREATIVE PROCESS

You don't have to recruit the opinions of others as your project progresses. Instead, rely on your own sense of design, color, and style to move forward. Working on an improv quilt challenges you to rely on what you see and feel, not what you think. Use your innate gift of intuition, not your intellect, to guide you. When the final outcome pleases you, your quilt is perfect.

REMOVE BARRIERS TO SUCCESS

This step—the design development of your quilt—can be the most fun or the most harrowing part of the process. Here are the biggest culprits that cast a shadow on this potentially sunshine-y experience:

TIME The clock is the greatest tyrant. If you let time be your boss and have a deadline hanging over your head, you will fuss over the wrong things.

EFFICIENCY The discipline of buying the exact amount of fabric and using every little scrap will not help you design an improv quilt. You need wiggle room to try out different ideas. This means having extra fabric on hand and seeking out more as needed. Also, do not hesitate to let go of a planned fabric. You'll find another use for it.

DOUBT Being frozen in your tracks because you don't believe in your design will result in frustration and more UFOs in your sewing studio. If your quilt designs don't exactly mimic the quilts in the photos, you are doing just fine. The book is not only an invitation to try something new but also to create something new—something that is totally yours.

OPPOSITE: IT IS TIME TO TRY OUT VARIATIONS WITH THE TRIMMED QUILT BLOCKS ON THE DESIGN WALL.

(1) THE PALETTE IS SOFT AND THE UNEXPECTED VISITOR IS PINK.

(2) THE PINK BECOMES PART OF THE OVERALL COMPOSITION AND MEDIUM GRAY IS THE UNEXPECTED VISITOR.

(3) THE THREE SOLIDS ARE AGGREGATED AND BLACK IS THE UNEXPECTED VISITOR.

(4) THE SOLIDS ARE ALL NEUTRALS AND GREEN-GRAY IS THE UNEXPECTED VISITOR.

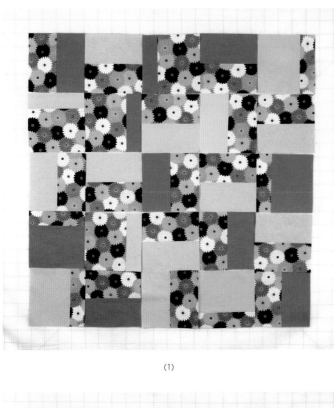

(1)

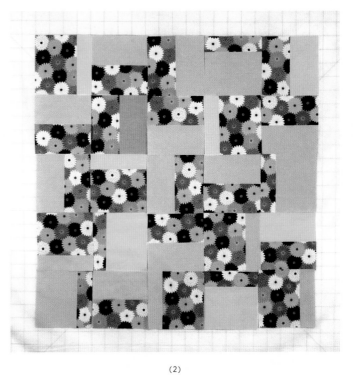

(2)

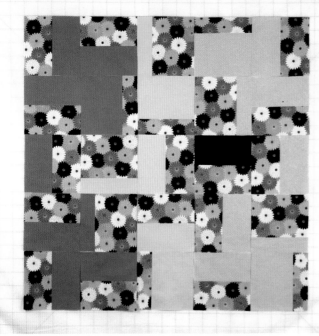

(3)

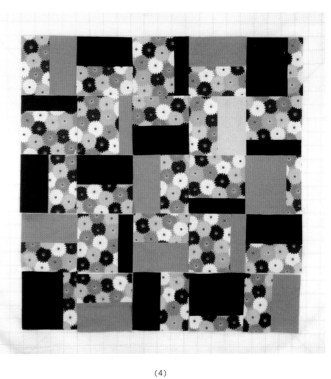

(4)

Assemble Your Quilt Top

NOW YOUR DESIGN ALL COMES TOGETHER

Once you are satisfied with your quilt top design, you sew the top together. Start by taking small squares of paper and writing a number on each piece—1 through the number of horizontal rows you have. (Get in the habit of underlining each numeral in case the number of rows grows to 9. You don't want to confuse 6 with 9.)

Pin the numbered papers on the left-hand block of each row, with 1 as the top row. Make sure the numbered papers are upright, not at an angle.

Make Piles Ready for Sewing

Pick up the left-hand block of the first row and place it squarely on top of the block to the right. Continue until all the blocks from the first row are in a pile, with the left-hand block on top and the farthest right-hand block on the bottom.

Make similar piles for all the remaining rows of blocks.

Place the pile for the first row on top of the pile for the second row, on top of the pile for the third row, and so on.

Place this impressive pile beside your sewing machine with the bottom edge of the blocks parallel to the edge of the table. Be mindful to not let this pile spin, or you may sew incorrect sides of the blocks together.

Sew Piles into Horizontal Rows

Flip the top block onto the block below it so the right sides of the fabrics are together. Sew the shared side with a ¼-inch (6-mm) seam allowance.

You don't need to pin the two pieces of fabric together; just make sure you have aligned the blocks along the top and bottom. Hold them neatly together so neither piece becomes skewed as you sew the seam. You also do not need to use a reverse locking stitch at the top or bottom of the seam.

Continue adding more blocks to the row. Make all the rows by sewing blocks together from left to right. Always start with the numbered block on the left. Do not remove the numbered papers.

Press the Rows
Press the seam allowances of the odd-numbered rows to the left and the seam allowances of the even-numbered rows to the right. This pressing step creates the ditch for stitching-in-the-ditch when you finish your quilt.

Sew the First Two Rows Together
Place the first row on top of the second row so the right sides of the fabrics are touching. Pin the two rows together along the shared seam. Lock the opposing seams of the blocks tightly together as you pin the rows.

Sew the long seam between the two rows with a ¼-inch (6-mm) seam allowance. Check your sewing to see if any seams on the back got caught in the stitching. If so, rip out a few stitches and re-sew.

Check the intersections where the corners of the blocks come together. If you want to make an adjustment, rip out the stitching for 1 inch (2.5 cm) on either side of the intersection. Nudge the fabric so it aligns better and re-sew.

Press the Long Seam
Press the seam between the first two rows up.

Finish Sewing the Quilt Top
Continue sewing the rows together and pressing the long seams up. Once the quilt top is complete, remove the numbered papers.

ADD PAPER LABELS TO THE LEFT-HAND BLOCK OF EACH ROW TO KEEP THE PROJECT ORGANIZED WHEN THE BLOCKS COME OFF THE DESIGN WALL.

PRESS EVERY SEAM THREE TIMES

With ironing, you slide the iron over your fabric. Pressing is different: You push the iron into the fabric, lift it up, and push it down again further along. The weight, heat, and steam of the iron flatten the fabrics.

Press each seam as you go along:
1. Turn your iron to the cotton setting. Position the seamed pieces on your ironing board, unopened, just as sewn. Place your iron on top of two seam allowances and press. This is called setting the seam, and it takes the tension out of the threads sewn through the fabrics.
2. From the back side, press the seam in the direction instructed—open or with both seam allowances to one side.
3. Flip your piece over and press the seam from the front. This final press ensures the seam is completely flat.

OPPOSITE:
(TOP) THIS PILE OF BLOCKS IS READY TO BE SEWN TOGETHER.

(BOTTOM LEFT) SEW THE BLOCKS TOGETHER IN LONG ROWS.

(BOTTOM RIGHT) PRESS THE SEAM ALLOWANCES OF EACH ROW TO ONE SIDE.

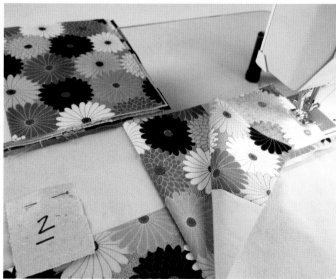

Finishing
Steps

The Fun of Finishing

YOU ARE HALFWAY DONE

Typically the glory of quilt making comes from the oohs and aahs that result from showing off the front of your quilt. Developing your quilt top is challenging and gratifying when all the pieces come together. Isn't the rest of the quilt-making process one big material-handling task? Not necessarily.

Your use of fabrics and the design of your quilt back can extend your quilt theme to a second side. Additionally, your simple quilt can be elevated to a remarkable one with your stitching—whether by hand or machine. Finally, an artful facing can add one more element of intrigue to your project.

If you choose to finish your quilt yourself, this section covers pin basting your quilt sandwich, stitching-in-the-ditch, hand quilting, blocking, trimming, and facing your Hachi Quilt. If you prefer handing off your project to a pro for sandwiching and long-arm stitching, consider adding an end cap facing that complements your improv design.

Use any finishing instruction that suits you, your style, and your available time. Remember: You are in charge of your quilt project.

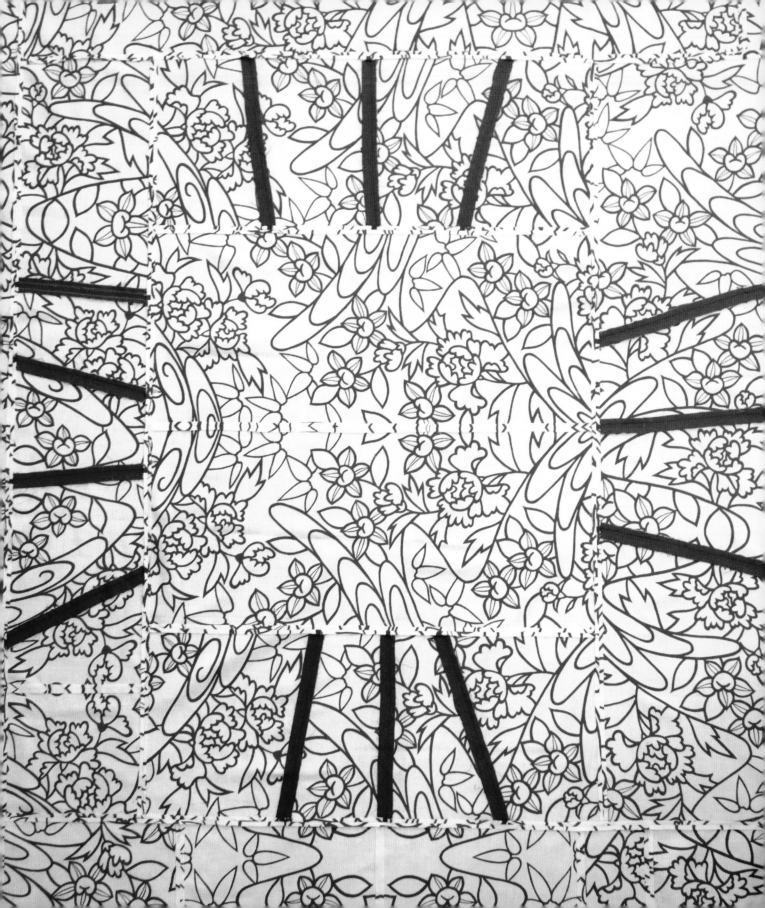

Make Your Quilt Back

EXTENDING YOUR DESIGN THEME

Some quilters use throw-away fabric for their quilt backs, explaining that "it's just for the back." I would say, instead, "It *is* the back." Every design decision is important when making a quilt.

That said, the back of each quilt should be a pleasing, coordinated, and even clever element that supports the quilt top but doesn't compete with it. This symbiotic relationship means that one does not thrive without the other. The design of the quilt back exists because of the fabrics and design of the quilt top.

Sometimes I know what fabrics I want to use for my quilt back while I am working on the top. Other times, I wait to see the finished top and then audition fabrics for the back. About a third of the time I make a back that's completely different than what I anticipated when I started the quilt project. Like me, you will strive to keep your thinking cap on as you move to the finishing stages.

To make a back, piece fabric together until it is 8 inches (20 cm) wider and 8 inches (20 cm) longer than your quilt top. A good general rule is to avoid a seam up the center: Quilts are often folded down the middle, so a seam there will wear faster. Remember, the facing will add one more design detail to the back of your quilt.

The Quilt Sandwich

TEMPORARILY SECURE THE TOP, BATTING, AND BACK

Make sure you have ample time for this step, as you will be taking over an extensive amount of floor space for an hour or two. Use cotton batting with scrim for your Hachi Quilt. This specially manufactured batting guarantees that your quilt will stay stable with stitching up to 10 inches (25 cm) apart.

First, check the sizes of the three parts of your quilt sandwich:

1. The quilt top is whatever size you made it.
2. The quilt back is approximately 8 inches (20 cm) wider and 8 inches (20 cm) longer than the quilt top.
3. The batting is approximately 8 inches (20 cm) wider and 8 inches (20 cm) longer than the quilt top.

To get started, press your quilt top and quilt back. Press the batting, too, if needed. I buy batting in bags, so I always need to press out the creases. Reduce the temperature of your iron, as the batting for Hachi Quilts has polyester scrim in it. If the batting is only lightly furrowed, you can throw it in the dryer on low for 10 minutes to fluff it up.

I assemble quilt sandwiches on the floor. (You may have your own method for pin basting on the wall or on a table.) I have used wood, stone, and carpeted floors. My preference is wood floors, as I use the parallel edges of the floorboards as a reference for lining things up.

You have to lean over and stretch when preparing the quilt sandwich, so wear comfortable, loose clothing and take off your shoes.

- Place the quilt back on the floor, right side down.
- Use masking or painter's tape to tape down the center of the top and bottom edges, and the center of the sides.
- Add more tape to the edges until the quilt back is squarely affixed to the floor and not skewed.
- Center and tape the batting over the quilt back so it is flat and taut.
- Place the quilt top, right side up, on top of the batting and back.
- Do not tape the quilt top to the floor.
- If the quilt top and back need to be aligned in a specific way, now is the time to finesse the position of the quilt top for that detail.

Special safety pins are used to faux baste the quilt sandwich together. Basting pins look like 1-inch (2.5-cm) safety pins, except the spear is slightly bent or curved.

- Starting at the center of your quilt top, slip the pin through all three layers of the quilt sandwich. When the tip of the pin reappears, close the pin with a Kwik Klip, the serrated edge of a grapefruit spoon, or the tip of a screwdriver. You can use your fingers, but they will soon be sorely pricked.
- Keep smoothing out the quilt top and pin baste, block by block. You will be stitching-in-the-ditch along the block seam lines, so pin inside the blocks. Six pins per block is sufficient.
- Once you have finished pin basting, remove the tape and pull the quilt sandwich off the floor.

OPPOSITE:

(TOP LEFT) TAPE THE BACK OF THE QUILT TO THE FLOOR, RIGHT SIDE DOWN.

(TOP RIGHT) TAPE THE BATTING OVER THE QUILT BACK.

(BOTTOM LEFT) PLACE THE QUILT TOP ON TOP OF THE BACK AND BATTING.

(BOTTOM RIGHT) SECURE THE THREE LAYERS OF THE QUILT SANDWICH WITH PIN BASTING, WORKING FROM THE CENTER OUT.

GOOD HOUSEKEEPING

Do you need to tidy up the back of your pieced top before making the quilt sandwich? If the background color of your fabric is white or light, the answer is yes—otherwise, the threads will show up in the finished quilt.

Take the time to trim the frayed fabric threads and leftover sewing threads with a small pair of scissors. Be careful not to nick your quilt! Then use an adhesive lint roller to collect all the loose threads.

BEFORE

AFTER

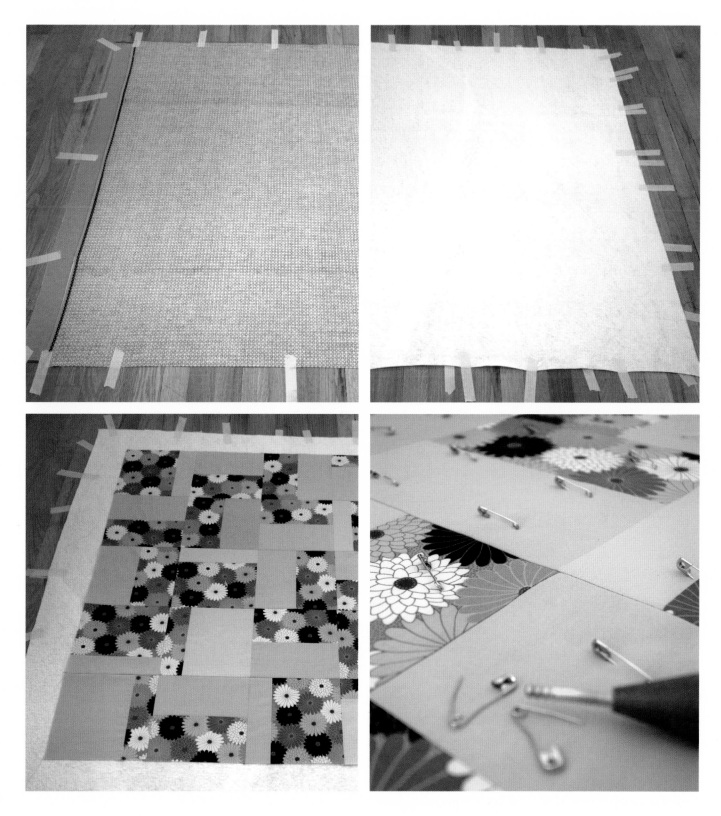

Stitching-in-the-Ditch

MACHINE STITCHING HOLDS YOUR QUILT TOGETHER

When assembling your quilt top, you pressed the seam allowances between the blocks to one side. From the front of your quilt, these seams have a high side and a low side. The low side is known as the ditch.

Stitching-in-the-ditch means stitching as close to the seam as you can on the low side. Essentially you are stitching in the shadow of the high side, so the stitches are somewhat hidden on the front and visible on the back.

To get started, prep your machine. Clean it, replace the needle, and check your stitch tension. You want this stitching to look good upon inspection. It's the same amount of work to make good stitches as poor stitches, so take a few minutes to prepare.

Change out your presser foot to a walking foot that draws all the quilt layers through your machine evenly. Grab your grip gloves. Test everything on a mini quilt sandwich with two pieces of your quilt fabrics on either side of a scrap of batting. Double-check the color, length, and look of your stitching.

I use 50 wt. cotton thread for stitching-in-the-ditch. Load up your machine with a thread that matches the colors of your quilt top and blends with your quilt back. If you use different thread colors for the front and back, choose similar hues.

I once stitched a quilt with yellow thread on top and navy on the back. Everywhere I microstitched looked like a little bruise. When I finished the whole quilt, I couldn't live with the result and picked out the stitches before starting all over again. This happened because I was in a hurry and forgot to really look at what I was doing. I paid the price of giving too little thought to this production step.

TIME TO CONCENTRATE AND GET STITCHING

Your first two lines of stitching go completely across the quilt sandwich, from top to bottom and side to side, and create a cross in the middle. There is no need for reverse stitching at the ends of these rows of stitching. You shouldn't bump into any basting pins, given that you didn't pin across any seams.

Your next lines of stitching run out from the initial rows of stitching, like tributaries, and fill in the four quadrants.

When you start your stitching in the middle of the quilt, you need to lock your first stitches. Set up your stitch length dial to make tiny stitches. Begin by stitching six to eight micro stitches to lock the threads.

To continue sewing to the edge of your quilt, adjust your stitch length dial to make regular-length stitches. There is no need to reverse lock at the end of the row of stitching if it is running off the edge of your quilt.

STAYING IN THE DITCH

It takes concentration to stitch super close to the seam. You don't want your stitching to jump onto the high side or to veer too far away from the ditch, where it becomes more visible. And be aware that the ditch switches sides on the vertical seams as you move to a new row.

Be sure to squarely line up your quilt as you feed it under the walking foot. If your quilt is heading into your sewing machine on an angle, you will fight to make straight stitches along your seams.

As you finish stitching each quadrant, remove the basting pins (except for those along the edge of your quilt). This reduces the bulk of the quilt and shows you where you still need to stitch. It also gives you a sense of accomplishment.

Once you've finished stitching-in-the-ditch, you should have basting pins along all the edges your quilt sandwich. If not, smooth out the quilt top on all the edges and fasten with straight pins. Tailor baste all around your quilt and remove the basting pins or straight pins.

STITCHING GONE AWRY

Your stitching may jump onto the high side of a seam, or it may wander away from the ditch. If you are dissatisfied with any of your stitching-in-the-ditch, just take it out. With your ripper, remove the stitching to a good starting and ending point. Restitch, using micro stitches to start and finish the correction, and regular-size stitches in the middle.

(LEFT) CROSSED PINS MARK A TROUBLED AREA THAT NEEDS TO BE RESTITCHED.

OPPOSITE:
(TOP LEFT) TEST THE STITCH LENGTH, TENSION, AND THREAD COLOR WITH A SAMPLE QUILT SANDWICH BEFORE STITCHING-IN-THE-DITCH ON YOUR QUILT PROJECT.

(TOP RIGHT) A WALKING FOOT ENSURES THAT ALL LAYERS OF THE QUILT SANDWICH MOVE TOGETHER AS THEY ARE STITCHED.

(BOTTOM LEFT) TO GET STARTED, PULL THE BOBBIN THREAD UP THROUGH THE QUILT SANDWICH AND POSITION THE WALKING FOOT TO SEW ON THE LOW SIDE OF THE SEAM.

(BOTTOM RIGHT) AFTER THE QUILT IS STITCHED-IN-THE DITCH, SECURE THE PERIMETER WITH TAILOR'S BASTING.

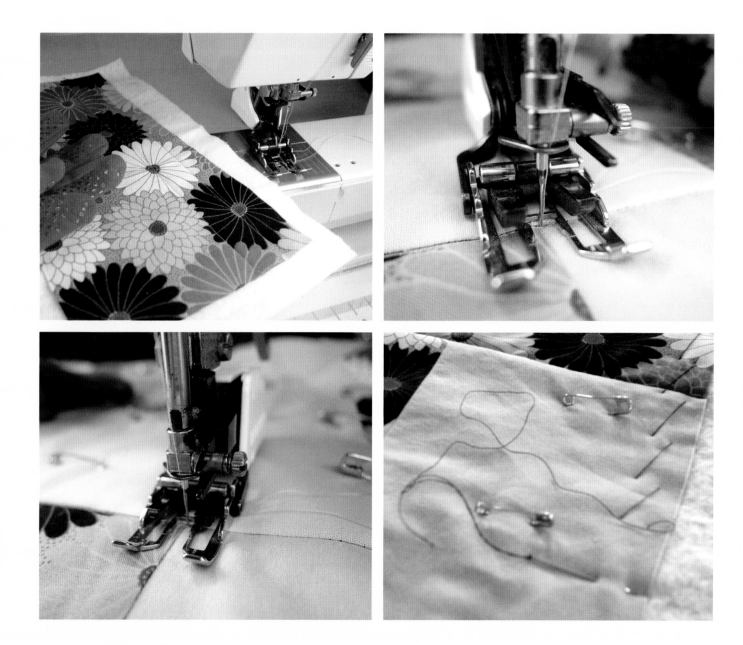

Hand Stitch Adventures

ENHANCE THE APPEARANCE OF YOUR QUILT

I challenge you to hand stitch every one of your quilts with a stitch pattern that you dream up. Perhaps your stitch design is a scaled-up shape from one of your printed fabrics or inspired by the theme of your quilt. No matter how you head into the stitching wilderness, I promise you won't get lost. You will have a charming adventure that will garner praise from all quilt aficionados.

Myriad tools are available to mark your stitching pattern. My favorites are a blue water-soluble marking pen that shows up on most fabrics and a white compressed chalk pencil that is visible on darker fabrics.

There are four easy ways to transfer your stitching idea onto your quilt top:

1. Direct: Draw stitching lines directly onto the quilt. You can use a straight edge (see Kabuki, page 51) or draw freeform lines directly on the quilt blocks (see Lotus, page 107).

2. Echo: Don't mark the quilt, but instead stitch around select forms in the printed fabrics. Estimate how far you want to be from the forms you want to outline and start stitching (see Hidden Wonders, page 73, and Sakura Spring, page 81).

3. Objects: Trace around found objects to mark the quilt. A set of vintage restaurant china provided the circular and oval forms for stitching Lucky Owls (page 91).

4. Freezer Paper: Draw your design on freezer paper, cut it out, iron it onto the quilt, and trace around the paper pattern. This method works well for a big idea, when you want to cover your whole quilt with a large pattern. Autumn Breeze (page 29) scales up a pattern motif from the backing fabric; Good Fortune (page 41) repeats the geometric whorl of a sunflower; The Art of Flowers (page 57) fills the quilt top with sixty leaves; and Nori-P (page 65) pays homage to the pop star with her signature.

OPPOSITE:
(TOP LEFT) FOR THE STITCH PATTERN OF KIKU, WELD TOGETHER THREE PIECES OF FREEZER PAPER AND DRAW THE DESIGN.

(TOP RIGHT) CUT OUT THE PATTERN, WITH CONNECTING BRIDGES, TO EXPOSE THE STITCH LINES.

(BOTTOM LEFT) USE THE HEAT OF A DRY IRON TO TEMPORARILY ADHERE THE SHINY SIDE OF THE STITCHING PATTERN TO THE QUILT TOP.

(BOTTOM RIGHT) TRACE THE EDGES OF THE STITCHING PATTERN WITH A BLUE WATER-SOLUBLE MARKING PEN.

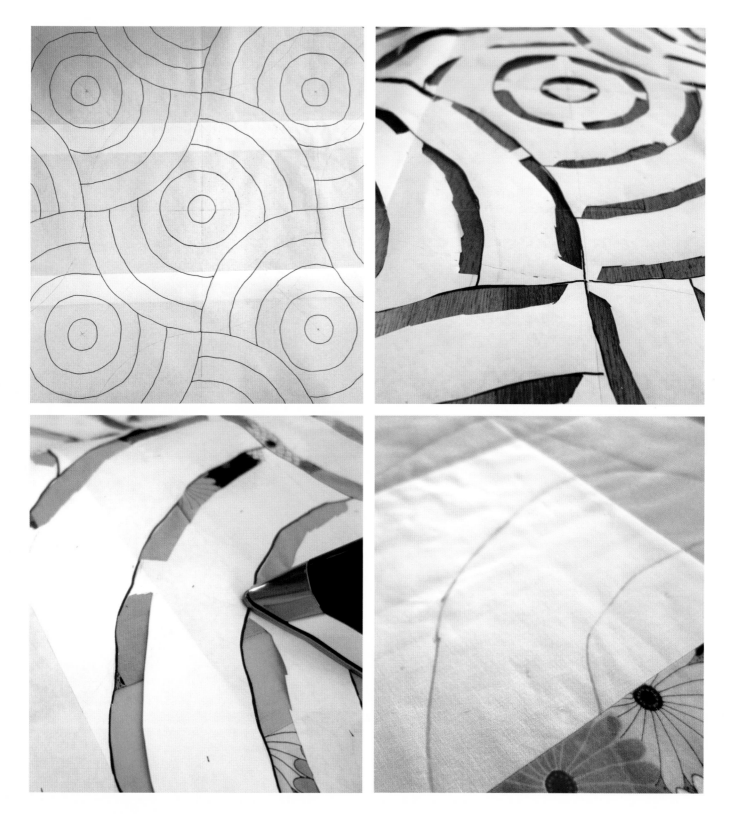

Lap Quilting

STITCH WHERE AND WHEN YOU WANT

Lap quilting means that you hand stitch with your quilt in your lap. It's as simple as that. There you are with a thimble on your middle finger, some thread on a needle, and lines marked on your quilt top. You don't need any great skill: Just push your needle straight down, then gently fold your project so the needle re-emerges straight up. If you don't hit a bulky seam, you should be able to take two or three stitches at a time.

WITH A THIMBLE ON YOUR MIDDLE FINGER, PUSH THE NEEDLE STRAIGHT DOWN INTO YOUR QUILT.

ONCE THROUGH THE QUILT SANDWICH, GUIDE THE NEEDLE BACK UP TO MAKE A STITCH. USE YOUR OTHER HAND TO PUSH UP ON THE QUILT.

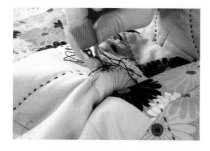

DIVE STRAIGHT DOWN AGAIN TO LOAD A SECOND STITCH ONTO YOUR NEEDLE.

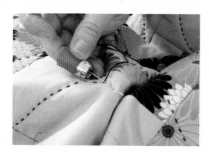

GUIDE THE NEEDLE BACK UP, WITH HELP FROM YOUR OTHER HAND UNDER THE QUILT.

Slow Stitching

Does free-motion stitching with your sewing machine feel like an out-of-control roller coaster ride? It can be a little daunting, especially after you have put so much work into your quilt project. Lap quilting is just the opposite.

Lap quilting is a true meditation, as your world shrinks to exactly 3 inches (7.5 cm) square. Quietly you follow the fine blue line winding across your quilt top. With lap quilting, you can fill your time at the airport, visit a friend in the hospital, sit on a train for hours, or wait in your car for an appointment. I spend lots of time watching movies on television when I'm hand stitching. I see half the film—when I'm pushing the needle down and when I'm pulling the thread through.

Lap Quilting Basics

Prepare for lap quilting by assembling a kit for hand stitching. Gather a sashiko needle, no. 8 or no. 5 perle cotton, a thimble, and small thread snips. Keep everything together in a small carrier, such as a pencil pouch, for easy transit.

Starting from the middle of your quilt sandwich, begin hand stitching. Work your way out from the center at all times. When you get near the outer edges, stop your stitching ½ inch (1.5 cm) from the edge.

Hide Those Knots

When you start stitching with a fresh thread, tie a knot near the end. One loop with perle cotton is usually the right-size knot. One inch (2.5 cm) away from where you want to start, angle dive the needle into the quilt top and just under the batting. Push the needle through your top fabric so it emerges at your desired starting point.

Pull your thread through the fabric until the knot bumps into the quilt top. Firmly tug on the thread so the knot pops through the fabric weave and becomes embedded in the quilt sandwich.

Hand stitch your design until you have only 4 or 5 inches (10–13 cm) of thread left.

Make another single-loop knot in your thread, this time manipulating the knot so it tightens up ⅛ to ¼ inch (3–6 mm) from the quilt top (the length of your stitches).

Take your final stitch by diving into the quilt top and under the batting, re-emerging about 1 inch (2.5 cm) away. Again, firmly tug on the knot until it pops into the quilt sandwich.

Trim at the thread where it exited: Tug on the thread a little, cut, and release the thread. Be careful not to clip your quilt.

Stitch Length

You can make your stitching any length you want. I average 5 stitches per inch with no. 8 perle cotton, and 2½ stitches per inch with no. 5 perle cotton. The most important thing is to stitch and not judge. Once you get started, keep going.

If your stitch length varies over the course of a project, it tells the story of your life. Your quilt may show how your skill level improved as you stitched. If your project took a long time to finish, your stitch lengths might reflect the various events you experienced along the way.

Your hand stitching is a gift you are giving to yourself, your quilt, and the world. Just relax with every minute of it.

Block and Trim

GET YOUR QUILT IN SHAPE

After hand stitching, the sandwich layers might be rippled or the whole quilt may be off kilter because of varying stitch density. Blocking is a finishing step that flattens all the layers together, straightens the edges, and squares the corners of your quilt.

To get started, take out the basting along the edge. Fill a bathtub or large sink with 3 inches (7.5 cm) of cool water. Be sure your fabric is colorfast before you proceed to the next step. If you prewashed your fabrics, it's a go. Otherwise, take snippets of your fabrics and wet them in a sink. If any dye discharges, do not proceed with wetting your quilt or it will bleed.

Slip your quilt into the water, swish it around, and lightly squeeze. Your fabrics and batting will not automatically absorb water like a sponge, so continue to agitate your quilt gently. After you think your quilt is completely soaked, leave it for another 10 minutes.

Pull the plug so the water drains out. Let the weight of the quilt press out some of the water. This is a great time to take a break. When you get back, wrap up the wet quilt in a towel. Gently squeeze to release more water.

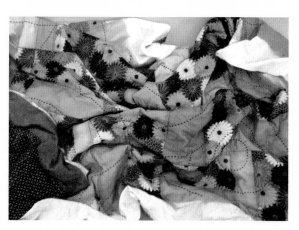

Using the original towel or a drier one, transport your quilt project to a blocking area. In my home, this is a carpeted floor that I cover with a clean sheet. Wall-to-wall carpet works well, as you can pin into the pile to secure your quilt.

(RIGHT) KIKU QUILT SOAKS IN THE BATHTUB TO REMOVE THE BLUE WATER-SOLUBLE INK AND GET PREPPED FOR BLOCKING.

Working from the center out, slap every block to flatten the fabric and smooth the three layers into one. Leave your quilt, unpinned, for eight to twelve hours, until it is almost dry.

Again slap every block, working from the center out. Measure corner to corner and edge to edge to see if your pinning needs to stretch any side of your quilt.

Using medium-weight pins, begin by pinning along the edge at the top and bottom, then both sides. Continue pinning around your whole quilt. Pull gently so your quilt is taut. This helps create a smooth, crisp finish.

About six hours later, when your quilt is bone dry, unpin and remove from the floor.

TRIM EXCESS BATTING AND FABRIC

Collecting my tools, setting up, and trimming a quilt sandwich very carefully takes me about 30 to 40 minutes for a medium-size project. This is a floor-based activity with lots of bending over, so I dress in soft clothes with no shoes.

Make sure your floor is clean. Double-check that your rotary blade is sharp, as you will be trimming through your quilt sandwich.

Place as many cutting mats as you have in a long line on the floor. Use masking tape to tape them together and then to the floor. If you have only one cutting mat, use the long side for trimming.

Place a long side of your quilt, right side up, on the cutting mats. Place a 4-foot (1.25-m) T-square on the bottom right corner, flipped so the flat surface of the T-square is in full contact with your quilt. (Or use your 24-inch [61-cm] grid ruler.)

Line up the T-square so the base aligns with the bottom of your quilt and the arm aligns with the right edge of your quilt.

Using your grid ruler, place it on the quilt side of your T-square arm and make sure your seams are running square under the ruler. Push and pull your quilt until it lines up squarely under the grid ruler.

Once you are ready to trim the first 4 feet (1.25 m), put your body weight on the T-square so it does not slip: Your right knee pins down the T-square and your left hand presses down on the far end of the T-square.

Stretch over and trim along the furthest 2 feet (61 cm) of the T-square. Then sit back and trim the first 2 feet (61 cm) of the T-square. You will not be able to trim the first 2 or 3 inches (5–7.5 cm), so slide the T-square directly back along the cutting line and finish trimming to the end.

If your quilt is longer than 48 inches (122 cm), reposition your quilt and T-square, and continue trimming the first side.

Turn your quilt so the next edge is on the long mats, square up everything, and trim. Continue trimming all three sides, making sure you have 90-degree corners when you are lining up the T-square and grid ruler.

Although trimming a quilt seems quick and easy, I go slowly. This is a moment of commitment, and if I don't make the first cut squarely, I will be disappointed.

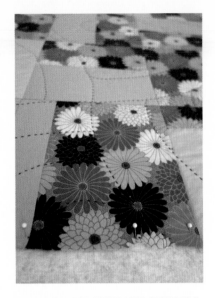

ON A CLEAN BED SHEET ATOP CARPETING, STRETCH THE DAMP QUILT INTO SHAPE WITH MEDIUM-WEIGHT PINS.

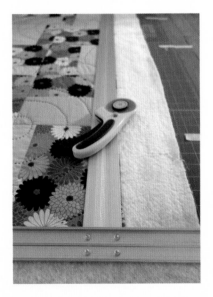

PREP THE QUILT TO BE TRIMMED WITH A 4-FOOT (1.25-M) T-SQUARE.

Extensions

(TOP LEFT) THE FACING STRIPS OF GLOW ARE BACKED WITH EXTENDER FABRIC MADE WITH BLUE COTTON BEHIND THE TURQUOISE SOLID AND WHITE COTTON BEHIND THE TOKYOIKS YUKATA COTTON.

(TOP RIGHT) THE BACKING FABRIC OF AYAKO IS EXTENDED WITH UNBLEACHED COTTON.

(BOTTOM LEFT) TO MINIMIZE THE USE OF YUKATA COTTON, THE BACK OF GLOW IS EXTENDED WITH UNBLEACHED COTTON.

(BOTTOM RIGHT) THE SLIVER OF EXTENDER FABRIC ON THE BACK OF YIN YANG WAS 4 INCHES (10 CM) WIDE UNTIL THE QUILT SANDWICH WAS TRIMMED.

WHEN YOU DON'T HAVE ENOUGH FABRIC

Who says you can't have a different fabric under your quilt facing than the rest of the backing fabric? Or that the back of the facing can't be a different fabric from the front?

Sometimes, especially when working with vintage or found materials, you run out of the fabric you want to use. There are two places where you can use extensions in Hachi Quilts—at the edges of your quilt backs and on the back side of your facings.

You can make extensions out of any fabric. I suggest a solid that is similar in value and weight to your other quilt fabrics. Or the fabric can be extra pieces from your quilt back, but running in a different direction.

End Cap Facings

Instead of a traditional double-fold French binding, make a facing from four strips of fabric that are stitched onto the front of the quilt and turned all the way to the back. This way none of the finishing shows from the front.

Making facings is an uncomplicated process, especially compared to double-fold French bindings that are best made with bias strips and somewhat difficult to get right.

Anything goes when you decide the width of your facing. My favorite width is 2¼ to 3½ inches (5.75–9 cm)—wide enough for any graphic piecing to show but narrow enough to lay flat. The narrowest facing I ever made was ¾ inch (2 cm) wide (see Pinwheels, page 63). This width required pressing with a tailor's clapper to get the bulky facing flat. I have also made wider facings and found that they get a little puffy across the breadth of the facing.

First Things First

Before adding your facing, staystitch around the perimeter of your quilt so all the layers are secured. To do this, pin all the way around your quilt and stitch ⅛ inch (3 mm) away from the edge with your walking foot.

Look at the design of your quilt top and back, as well as available fabrics, to determine how you would like your facing to look.

If possible, make your facings using the long grain of your fabric so there is less stretching.

Facing Basics

- A facing strip can be pieced, bordered, angled, or all one fabric.
- Press open any seams within the facing.
- Position the nonfolded or open edge of facing strips along the edge of the quilt sandwich.
- Place all strips on the front of the quilt, stitch, and turn to the back.

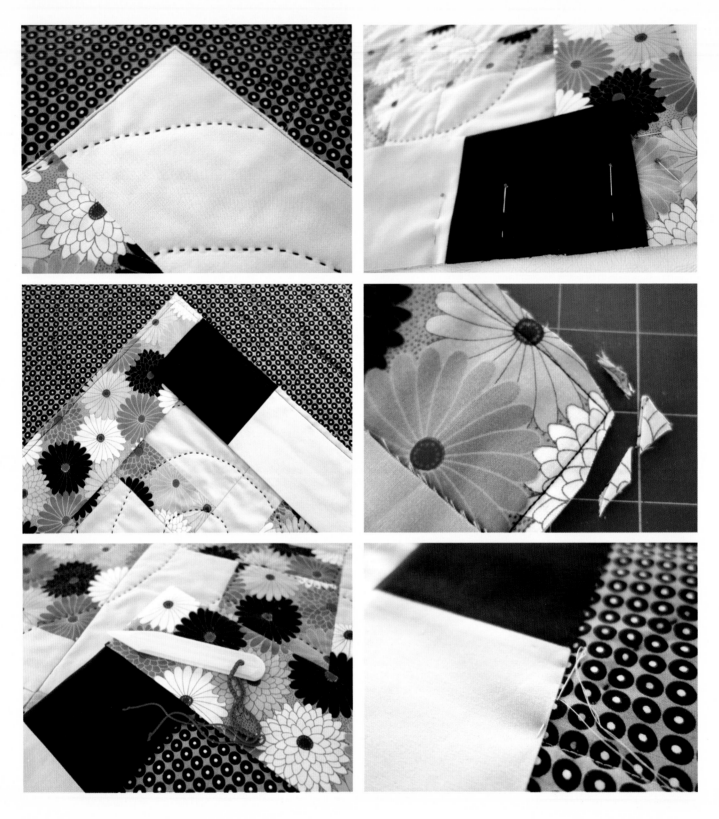

Two facing strips are the exact width of the quilt, and two other facing strips are slightly shorter than the length of the quilt. The shorter facing strips are positioned on top of the two spanning the width of the quilt.

Position and pin all facing strips on the front of the quilts. Using a walking foot, stitch around your quilt front with a ¼-inch (6-mm) seam allowance. Start in the center of a side. When you get to the corners, pivot smartly to create 90-degree angles. Reverse stitch at the beginning and end of your stitching.

Trim across the corners, close to the stitching. Trim angled slivers off the side seam allowances at the corners to reduce bulk.

Set the seam by pressing the facing and quilt flat together. Then press the facing away from the quilt top wherever you can. Don't worry about getting close to the corners.

Turn the corners with a point turner. Do not use a sharp object like a seam ripper, which can tear through your delicate corners.

Press the facing to the back. You want quilt/facing seam to be in the center of the quilt edge. If you have a tailor's clapper, flatten the edge a little more by pressing the clapper down on the edge after each steam press of the iron.

Use an invisible or blind stitch to hand stitch the facing to your quilt. Match the thread color to your facing fabric. If the facing is made with a variety of different-colored fabrics, use a variety of thread colors to match.

The best stitch length is ¼ inch (6 mm) or ⅜ inch (1 cm). Each time you get to a sixth stitch, take a double stitch to lock your blind stitching.

Press your quilt edges one more time to flatten out any tension from the hand stitching. Ta da! You are done.

THREE FACING VARIATIONS

1. **Single-width facing.** Make facing strips ⅞ inch (2.25 cm) wider than the desired final facing. Press one edge under ⅝ inch (1.5 cm). Position the strips on the top of the quilt with the pressed edges up and toward the center of the quilt. Sew around the perimeter and turn to the back. This style of facing may have some see-through.

2. **Double-width facing.** Make facing strips 2X + 1 inch (2.5cm) wider than the desired final facing. For example, strips for a 3-inch (7.5-cm) facing are 6 inches (15 cm) + 1 inch (2.5 cm) for 7-inch- (18-cm-) wide strips. Once you make the strips, whether pieced or whole cloth, press them in half lengthwise. Then trim the folded strips to the final facing width plus ¼ inch (6 mm). For the preceding example, the strips pressed in half are 3½ inches (9 cm) wide. Trimmed and ready for use, the strips are 3¼ inches (8 cm).

3. **Double-width facing made with extensions.** When you don't have enough of the desired fabric to make double-width facing strips, you can seam extension fabric to the desired fabric and make long strips. When you press the strips lengthwise, make sure some of the desired fabric rolls to the back side. Position the facing strips on the quilt front with the extension fabric up for stitching.

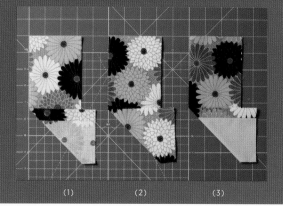

(1) (2) (3)

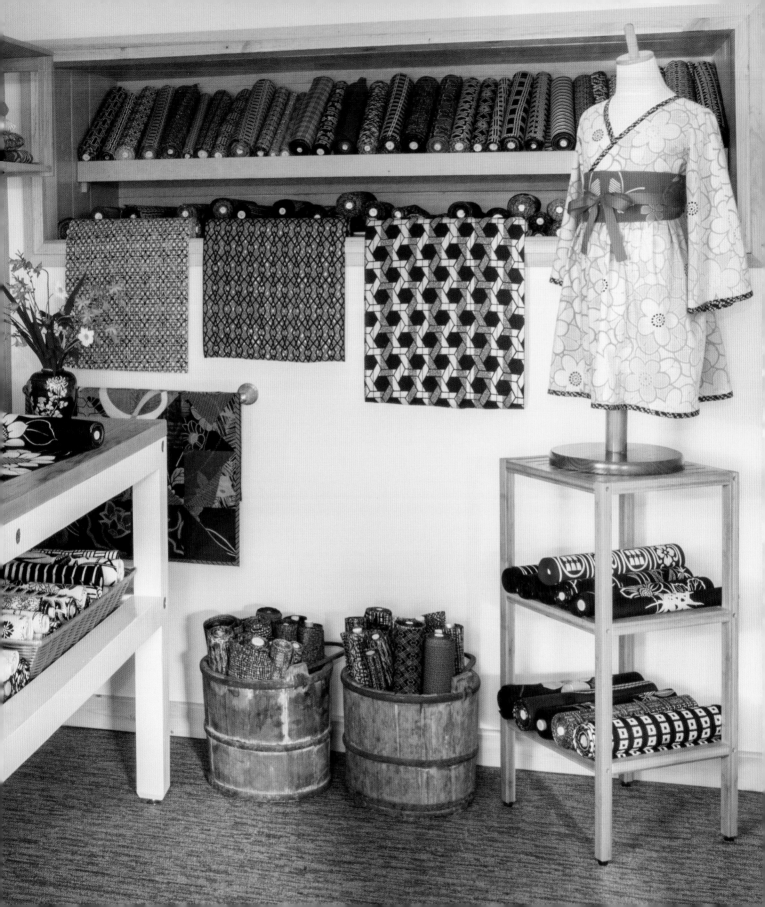

Japanese Textile Resources

This is not a comprehensive list of all the places where you can procure Japanese fabrics. To start, please visit your local quilt or fabric shop and ask about Japanese fabrics. You can also search for yukata cottons and Japanese textiles online at eBay or Etsy, or via your favorite search engine.

- -

Australia
- **BeBe Bold** bebebold.com
- **Clair's Fabrics** clairsfabrics.com
- **Indigo Niche** indigoniche.com
- **Japanache** japanache.com.au
- **Kazari** kazari.com.au
- **Kelani Fabric Obsession** kelanifabric.com.au
- **KimoYES** kimoyes.com
- **Wafu Works** wafuworks.com.au

Canada
- **Quilter's Dream Fabrics** quiltersdreamfabrics.com
- **Things Japanese** thingsjapanese.ca

Germany
- **Frau Tulpe** frautulpe.de
- **Volksfaden** volksfaden.de

Hong Kong
- **ModeS Group** modes4u.com

Japan
Look through antique shops, old kimono stores, and flea markets for yukata bolts. Just ask for "vintage yukata tanmono."
- **Blue & White** blueandwhitetokyo.com
- **Fabric Tales** fabrictales.com
- **Ichiroya** ichiroya.com
- **Kimono Boy** kimonoboy.com
- **Nippon Town, Tokyo**
- **Nomura Tailor** nomura-tailor.co.jp
- **Quilt Party, Ichikawa City**
- **Yuzawaya** yuzawaya.co.jp

Netherlands
- **A Boeken** aboeken.nl

New Zealand
- **Kiwi Quilts** kiwiquilts.co.nz
- **Kiwi Threadz** kiwithreadz.com
- **Raku** raku.co.nz
- **Stitchbird Fabrics** stitchbird.co.nz

Spain
- **Nunoya** nunoya.com

USA
- **Circa 15 Fabric Studio** circa15fabricstudio.com
- **Fabric Indulgence** fabricandart.com
- **Fabricworm** fabricworm.com
- **Kasuri Dyeworks** kasuridyeworksfabric.com
- **Okan Arts** okanarts.com
- **One World Fabrics** oneworldfabrics.com
- **Quilting Foxes** quiltingfoxes.com
- **Shibori Dragon** shiboridragon.com
- **Sri** srithreads.com
- **Superbuzzy** superbuzzy.com

UK
- **Euro Japan Links** eurojapanlinks.com
- **Japan Crafts** japancrafts.co.uk
- **Susan Briscoe Designs** susanbriscoe.com

Acknowledgments

There are many people who helped bring this book to fruition. A special thank-you to my husband, Michael, who kindly supported me in all my doings. And to my family members who took care of me so generously. And to my friends who I ignored more than I would like to admit.

I created the first Hachi Quilt with vintage yukata cotton given to me by Ann Darling and artfully overprinted by Peggy Juve. Little did I know at the time that their gifts would launch a series of life-changing quilts.

Many quilting pals donated treasures from their stashes for the quilts with contemporary fabrics. Leslie Nellermoe in particular brought me a huge bin of fancy reproduction cottons that inspired Gilded Garden and Kiku. And Joe Cunningham gave me the outrageous dot fabric in Festival.

I pilfered the homes of my Japanophile friends to collect props for the photo shoot—thank you Heidi Ob'bayi, Leslie Ross, Kathy Hattori, and Leslie Mehren. Megumi Kanzaki and Todd Kuniyuki shared their delightful daughter, Emilee, who you see wrapped in Hidden Wonders and in her yukata. The backdrop for the quilt photos is the waterfront home of the gracious Gloria Pfeif.

In Japan, I give my deepest appreciation to Dr. Mima and his wife, Yoko, for the gift of the formal yukata I boldly cut up for the back of Kabuki. And to Amy Katoh, who leads the charge of preserving traditional arts and crafts in her adopted land.

Three Seattle people helped bring the concept of this book to life: Carol Waymack, John Bisbee, and Rowland Crawford.

Top-quality supplies were provided for making the Hachi Quilt Collection: Aurifil (threads), Colonial Needle (perle cotton), and Hobbs Bonded Fibers (batting).

An enormous thank-you to the whip-smart East Coast folks who ensured my success in completing this three-year project: my agent, Linda Roghaar; my editor, Shawna Mullen; my technical and copy editor, Sarah Rutledge; and my team at Abrams: managing editors Alicia Tan and Mary O'Mara; graphic designer Chin-Yee Lai; creative director John Gall; and production manager Rebecca Westall.

Finally, this book is filled with gorgeous photos because of the brilliance of photographer Kate Baldwin and the magic of stylist Malina Lopez.

About the Author

At age 50, PATRICIA BELYEA took her first trip to Japan. At 53, she made her first quilt. Five years later Patricia left the creative agency she had led for 25 years to become a full-time quilter and importer of vintage Japanese textiles.

Once she started quilting, Patricia worked on projects during every waking hour (and hours she should have been sleeping). "I was a fish who didn't know I was a fish until someone showed me the water," she explains.

Once she discovered vintage Japanese yukata cottons, Patricia had found her calling. These hand-dyed fabrics with graphic patterns and luscious colors were not common in quilting circles. Yet the quality and design of yukata cotton seemed ideal for making stunning quilts.

Today Patricia possesses the largest collection of vintage yukata cotton outside of Japan. A yukata-cotton evangelist, she sells these Japanese textiles from her petite home-based shop, Okan Arts, in Seattle and through her website, okanarts.com.

Editor: Shawna Mullen
Designer: Chin-Yee Lai
Production Manager: Rebecca Westall

Library of Congress Control Number: 2016960609

ISBN: 978-1-4197-2659-0

Printed and bound in China
10 9 8 7 6 5 4 3 2 1

Abrams books are available at special discounts when purchased in quantity
for premiums and promotions as well as fundraising or educational use.
Special editions can also be created to specification. For details, contact
specialsales@abramsbooks.com or the address below.

ABRAMS
The Art of Books

115 West 18th Street
New York, NY 10011
abramsbooks.com